MEDIEVAL CRAFTSMEN

PAINTERS

PAUL BINSKI

UNIVERSITY OF TORONTO PRESS

TORONTO BUFFALO

For Boonette

© 1991 British Museum Press
First published in
North America 1991 by
University of Toronto Press
Toronto, Buffalo

ISBN 0-8020-6918-5

Designed by Roger Davis
Set in Palatino
Phototypeset by Southern
Positives and Negatives
(SPAN), Lingfield, Surrey
Printed and bound in
Hong Kong

Front cover A female painter
Thamar portrays the Virgin Mary,
depicted in Boccaccio's *De Claris
Mulieribus*. See fig.**7**.

Back cover St Luke, the patron
saint of painters. See fig.**2**.

Title page An early representation
of St Luke as a painter, from the
Gospel Book of John of Troppau.
See fig.**13**.

This page Lay painters at work on
a carved image of the Virgin
Mary (compare with fig.**24**);
to the left, colours are ground on
a block. From *Las Cantigas* of King
Alphonso the Wise of Castile, late
thirteenth century.

Contents

INTRODUCTION

This book is about painters and the craft of painting during the Middle Ages in Western Europe. It concerns painting, the colouring of plastered walls or wooden panels or other larger-scale surfaces, rather than illuminating, the smaller-scale decoration of vellum or paper with paint and gold leaf. The fact that illumination is sometimes mentioned in this study indicates that it was never entirely separate from painting. Both involved the art of the brush. However, medieval painting and illuminating employed different materials and were, on the whole, practised by different people and seen by widely differing audiences.

The subject-matter of this study is drawn mostly from the period after about 1100, coinciding roughly with late Romanesque and Gothic art. This is not because the achievements of Romanesque and Byzantine painting (the latter is not considered here for reasons of space) were negligible. Rather, it is because of the nature of the available evidence.

What we know about medieval painters depends upon two things: the survival of their products, the paintings, and the survival of other types of evidence, usually written, about the painters and their craft. Before the twelfth century, surviving wall and panel paintings are easily outnumbered by illuminated manuscripts, which were more likely to find the protection of a library. The number and variety of extant paintings dating from the thirteenth century onwards is much greater; it may be that more survived because far more were being produced. Later medieval culture certainly required new types of painting, of which a good example, almost unknown before the twelfth century but common thereafter, is the altarpiece. Altarpieces proliferated in the thirteenth century because of changes in thinking about the symbolism and importance of altars, considerations related more to liturgy and doctrine than to art. Together with murals and smaller panels, altar panels of all types make up a large proportion of surviving medieval paintings. More generally, the gradual growth of the medieval economy, especially from the eleventh and twelfth centuries onwards, produced more — and wealthier — patrons both within the Church and outside it, and so stimulated and diversified demand for the painter's work. The Middle Ages saw profound changes in the nature of the demand for painting, and consequently in its character and incidence.

The survival of painted objects is, however, only one half of the equation. On their own, they could not be the basis for anything other than the most general inferences about the craftsmen who made them. For more specific knowledge, another process was necessary, namely a change in the way medieval society produced records, and so documented itself. Our idea of what constituted a medieval painter depends on medieval writing and medieval terminology. Before the twelfth century the types of document which tend to mention specific painters were produced predominantly by the Church, were written in Latin, and were on the whole unconcerned with the activities of artists. Very little of real interest is known about individual painters before the twelfth century, and even less about painters in relation to specific paintings.

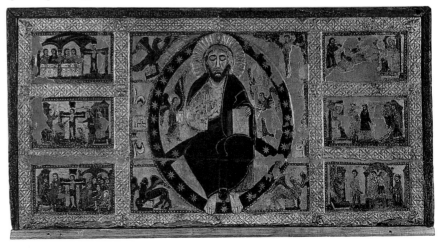

1 An Italian altar panel from the beginning of the thirteenth century, an early example of a new genre. Showing Christ in Majesty, the surface is embellished with gilt embossed gesso imitating metalwork. Within a century such panels increased immensely in popularity and scale.

2 St Luke, the patron saint of painters, portrays the Virgin Mary. Rogier van der Weyden, 1430s.

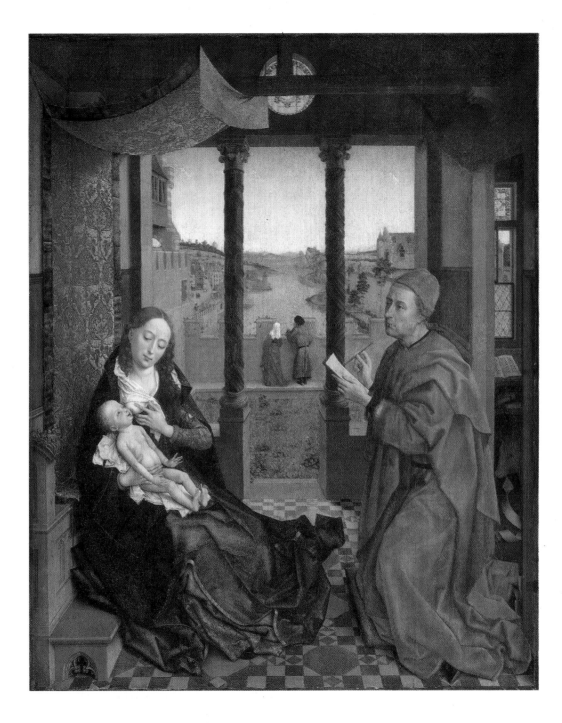

Between the twelfth and fourteenth centuries, however, medieval society as a whole witnessed a revolution in the transmission of information, which placed growing emphasis on precise written records and the increasing use of vernacular languages as opposed to Latin. This revolution affected the Church but gradually had its most profound impact on the secular world, in government, commerce and in the documentation of the individual. What we know about medieval painters, apart from incidental references in chronicles, is due almost wholly to secular administrative records, contracts, and wills. Just as paintings became more plentiful, so too did documents. Whereas the painter and the painting were previously almost always separate, the agency of the written record brought them gradually together, enabling us to construct a history of the painter and his works.

A valuable but often frustrating by-product of the revolution in medieval documentation was that more and more was recorded of the actual processes involved in painting. This took two forms. The first was the preservation in writing of descriptions of the procedures used by painters. Examples of painters' guidebooks, or 'how to do it' manuals, are rare and mostly later medieval. They are represented by two in particular: the monk Theophilus' twelfth-century treatise *De Diversis Artibus* (On the Various Crafts), probably written in Germany; and Cennino Cennini's early fifteenth-century *Il libro dell'arte* (The Handbook of the Crafts), written in Padua but recording traditions associated especially with Florence. The procedures recorded in these guidebooks were usually taught to apprentice painters by word of mouth, within the practical confines of the workshop. No-one knows why they should have been written down, since the genre has limited literary appeal. Works of this type are also tantalising because they remain vague on many points which are now of considerable interest: for example, while informative about painters' uses of materials and colours, they rarely say anything about why painters worked in the styles that they did, and about the intellectual processes involved in creating painted images.

Secondly, other documents, such as medieval administrative records, gradually became more particular about recording the day-to-day activities of painters associated with royal, aristocratic, ecclesiastical and civic patronage. They are not, however, neutral records. Administrative records, contracts and wills are sophisticated documents which few in the Middle Ages ever encountered, and which even today require specialised expertise to read and understand. In fact, most medieval paintings of the type found, for example, in parish churches throughout northern Europe are undocumented simply because their production did not require written documentation. Written records are both socially selective and bound by textual formulas of one sort or another; they cannot, therefore, give a full account of medieval painting, inevitably the most versatile and common art form of the time.

Neither paintings nor documents are evidence in themselves; they require one another, and are accordingly used side by side in this study, which also places more emphasis on the producer of paintings and his methods than on the paintings themselves. Yet process and product should not be divorced. Crafts such as painting were identified with specific materials and skills. By understanding these materials and skills and their effect in particular paintings, we understand something about the professional identity of the painter. This becomes increasingly apparent as methods of scientific examination unravel the techniques used by painters, and as art history continues to study why, and under what social arrangements, images were produced.

1 THE PAINTER

MONKS, LAYMEN AND WOMEN

Who were the medieval painters, and to what extent did their social identity change in the course of the medieval period? We can be fairly certain that, throughout much of the Middle Ages, painters were predominantly professional males. How then were they organised? One answer is that almost everywhere in western Europe, between the eleventh and fourteenth centuries, painters stopped being monk-craftsmen employed in Church communities, usually monasteries, and became lay craftsmen working in towns. The distinction between monk and lay professional is deeply rooted in the literature of art and, while not wholly inaccurate, is misleading for several reasons. Relations between the

monastic and secular worlds were more fluid than we imagine. Theoretically, for example, monks could not move freely from the monastery to the outside world. Yet in the thirteenth century one of the English royal painters was William, a Benedictine monk of Westminster Abbey and a contemporary of a monk shown painting a statue of the Virgin Mary in a thirteenth-century English illuminated manuscript. Nothing is known about William personally, but royal documents show that he undertook wall-paintings for the king at places as far apart as Westminster, Windsor and Winchester, and was therefore certainly mobile.

It is also probable that many monk-craftsmen began life as lay professionals trained in the outside world, who were only later drawn into monasteries. Such individuals would then appear in the local monastic chronicle as monks, not ex-laymen. One example, known to us through an exceptionally detailed chronicle, the *Deeds of the Abbots of St Albans*, is Walter of Colchester, a celebrated painter and sculptor who was brought as a layman to the great English Benedictine abbey of St Albans in the late twelfth century, and appears to have stayed on as a monk. Distinctions between monastic and lay craftsmen can thus be unhelpful and, while monks undoubtedly did paint, the role of lay craftsmen, certainly predominant by the fourteenth and fifteenth centuries, tends to be underestimated earlier in the Middle Ages.

Nevertheless, monastic written records are an essential, indeed often the only, early source. They have three characteristics. Their references to named painters (whether monks or not) are, first, usually casual: according to the oldest monastic rule, that of St Benedict, art manufacture was viewed as an acceptable activity in the cloister, but it was not a means of self-promotion. Its purpose was rather that of a penitential and basically humble meditation. Monastic sources tend, secondly, to demonstrate a much greater regard for objects made of

3 Monastic handiwork as *Opus Dei*. An English Benedictine monk colours an image of the Virgin and Child, *c*.1260. Holding a colour-dish, he has other utensils and brushes at his feet. A prayer to the Virgin is inscribed at the top.

precious materials than non-precious ones such as paintings. An excellent source representing this outlook is Theophilus' *De Diversis Artibus*, whose Romanesque classifications consider the manufacture of stained glass and metalwork separately from painting. Monastic and other ecclesiastical inventories of church possessions tend only to record precious movables. Thus gilded and jewelled metalwork altarpieces may receive mention where painted ones do not, despite the fact that painted ones may have been more common.

A third point about monastic sources is that, apart from reflecting a view of artistic creation based in biblical views of God as *artifex et conditor* (author and founder), they often preserve haphazardly the resilient and versatile literary formulas of antique writing. One such formula was the tendency to praise monks – a good example would be the praises heaped upon St Dunstan – for being gifted all-rounders, good scholars and good craftsmen, embodying the virtues instilled by the Benedictine rule. This notion of diligence and sufficiency in all things was derived from antique moralists and rhetoricians who attempted to link all aspects of human nature and conduct. Another such legacy was the notion of the excelling artist. Pliny, a Roman whose works were widely read in the Middle Ages, provided one example in his account of the painter Apelles who 'excelled all who came before or after him'.

It was a commonplace of antique writing on painting to demonstrate its high social standing and to associate the socially superior being, the great man, with its creation and appreciation. This type of hyperbole was later a feature of Renaissance artistic biographies, of the kind found in the writings of Ghiberti and Vasari in the fifteenth and sixteenth centuries. Yet wide-ranging competence was also valued in the Middle Ages. It was a thirteenth-century monastic historian, Matthew Paris, himself a gifted artist, who described the metalworker, painter and sculptor Walter of Colchester at St Albans Abbey as 'without equal in all kinds of skill, nor do we believe anyone will equal him in the future'. Of Matthew himself, it was also later said that

He had such skills in the working of gold and silver and other metal, and in painting pictures, that it is thought that there has been none to equal him in the Latin world.

Monastic documents, linked indirectly to the thought-processes of a bygone ancient world, and often themselves unspecialised, seldom establish a direct link to the medieval painter. Another potential, yet surprisingly rare, source is the painted image of the painter at work. Like monastic sources, medieval images of painters tend to have a classical or biblical context. The painter's image is most likely to appear in northern European illuminated manuscripts of the works of Cicero, Pliny and, later, Boccaccio. Such works were, of course, the product of professional illuminators rather than painters. That does not necessarily mean that their content is misleading. Medieval illustrations of antique texts referring to the renowned painter

5 The decoration of Solomon's Temple as envisaged in an early fifteenth-century French *Bible historiale*.

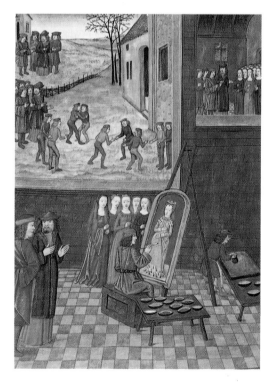

6 Medieval image meets antique idea. The Greek painter Zeuxis as imagined in a fifteenth-century illumination of Cicero's *De inventione*. Working at an easel, Zeuxis creates a composite image of female beauty, taking the best features from five models, the 'Maidens of Croton'. Note the apprentice and colour-dishes.

Zeuxis made no effort to do anything beyond depicting him in a run-of-the-mill painter's workshop, and in a narrow sense they tell us something reliable about his working environment. On the other hand, such depictions exemplify the awkward marriage of antique literary ideals of 'the artist', and the realities of late medieval craft production and 'the artisan', of which more will be said presently.

The discrepancy between literary ideal and social reality is widespread in our evidence. It can be felt especially in the treatment of women as artists. Women were often distinguished embroiderers and are known to have been illuminators: husband-and-wife teams of illuminators seem to have existed by the fourteenth century, and in the sixteenth century the German artist Dürer patronisingly baulked at the cost of a page illuminated by a woman. But there is very little documentary evidence that they painted panels or walls. Female involvement in the craft is documented and the documents may of course underestimate that involvement — by reason of the family-dominated nature of much medieval craft practice. In mid fourteenth-century England Matilda Myms, widow of John 'the imaginour', bequeathed her materials for making pictures to her apprentice, William: Matilda was the survivor, the relict, of a family painters' concern. In 1295 a Florentine woman married to a painter took on an apprentice for four years to teach him painting. However, women seem most often to have had a role in the craft equal only to that of the average apprentice, who was usually expected to prepare and fetch materials. In 1253, for instance, Matilda of Bexley was paid 25s. (a good sum) for 51 dozen of gold (i.e. gold leaf) for the use of royal painters at Westminster, and in the fourteenth century Dyonisia la Longe, gilder, is known to have supplemented her income by running a pub.

Such medieval realities contrast with the dainty, classically-inspired vision of three celebrated antique female painters, Thamar, Marcia and Irene, in Boccaccio's fourteenth-century work *De mulieribus claris* (On Famous Women). These artistic Amazons, of whom Boccaccio had read in Pliny, are pictured plying their trade in

9

7, 8 Scorning the usual occupations of women, female painters are shown in a French copy from 1402 of Boccaccio's *De Claris mulieribus*; Thamar (left) portrays the Virgin Mary while Marcia (right) executes a self portrait with the aid of a mirror. Note the colour-dishes on the tables of both illustrations (and see also figs.**3**, **51** and **64**).

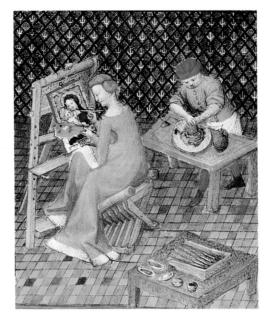

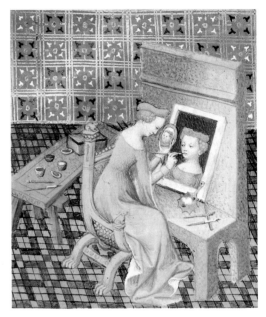

fifteenth-century French translations of Boccaccio's work. What impresses us about such illustrations, which sometimes bring home the point by including gruff male workshop menials and all the apparatus of the medieval painter's shop, is of course their coy inversion of the masculine nature of the trade as generally perceived and practised.

COURT PAINTERS AND GUILDS

Many of our sources thus give a partial, geographically restricted and even warped impression of who painters were. Others, dating mostly from the thirteenth century onwards, seem more reliable. Many are non-ecclesiastical documents, and tend by their nature to highlight the activities of secular professional craftsmen. Monks, unlike those in the outside world, were not allowed to have private property, and it is often as a result of ordinary worldly concerns that lay painters start to appear routinely in documents at this time. As often as not, they manifest themselves in tax records, or in documents relating to debt, probate, property transactions or felonies. For example, the first document mentioning the great thirteenth-century Italian painter Cimabue is a legal document totally unconnected with his art, the signing of which he witnessed in Rome in 1272. This document has the merit of connecting him with late thirteenth-century Rome and consequently with Roman art, and upon this connection other theories can be based. Painters also start to appear in the increasingly systematic documents of royal political and financial authority. Many of the French royal records were destroyed, but the plentiful English ones whose production burgeoned in the thirteenth century sometimes allow us to chart almost week by week the comings and goings of painters in the king's service, informing us about who was the current master painter, how many assistants he had, how much they were paid per week, what materials they purchased and (more rarely) what they were actually painting. They also record isolated moments of human generosity, as when Jack of St Albans, painter to Edward II, was rewarded in 1326 for having danced on a table — probably a workman's trestle table rather than at dinner — before the amused king.

This document, in Anglo-Norman French, also witnesses to the growing use of vernacular languages rather than Latin as a means of recording. We do not know what language was

9 *Above* An entry written in French in a royal account book of the reign of Edward II, rewarding Jack of St Albans, King's Painter, who danced upon a table before the King and made him laugh greatly ('qui daunsa devant le Roi sur une table et lui fist tresgrantment rire').

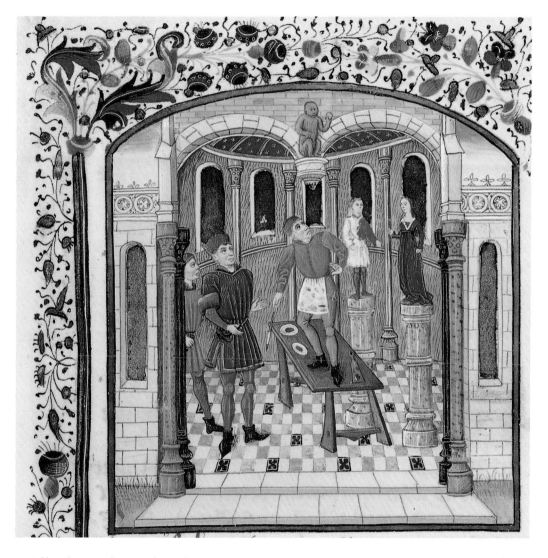

10 A fifteenth-century illustration from Valerius Maximus' *Fairs et dits memorables*, showing an Athenian painter perched on a trestle table, attempting with difficulty to represent the gods.

spoken by court painters like Jack: probably English and possibly some French. Latin would have been largely incomprehensible to him, as to almost all painters, and thus by the educated standard of the time he was illiterate. The use of English in documents became common by the fifteenth century, but occurs much earlier despite the fact that many documents continued to be set down in Latin. A royal account of 1307–8 charmingly blends Latin and current painter's English in including payments for thread (*thred*) and the making and repair (*factione et reparacione*) of brushes, called, in bad schoolboy Latin, *brushorum*.

The rise of court artists reflects the much more general centralisation and organisation of secular power which occurred throughout Europe in the Middle Ages. Kings were increasingly able to compete with ecclesiastical patrons. Nevertheless, French, English and Italian royal records show that the relationships of painters to the court remained for the most part informal until the fourteenth century. Royally-employed painters undoubtedly also worked for the few. non-royal patrons who could afford to hire them. This became more common in the fourteenth and fifteenth centuries as the social base of patronage broadened and offered more competition and a wider market, most notably in the middle ranks of society. It is exactly in this period, and as a response to such trends, that painters began to be entitled 'King's Painter' or were elevated to household posts within the court, most commonly (in France at least) *valet de chambre*. Such posts carried more prestige than duty, and provided the painter with socially-distinguished perks such as furred robes and access to the royal household. Above all, they kept the painter in the patron's service, acting as retainers in a period when some kings, such as Edward III of England (1327–77), had to impress painters into their service. Royal power was considerable – a king could oblige a painter to work on Sunday against his craft regulations – but it still had to compete with other patrons for talent. At this time, too, the language of the legal contract was hardening, and it is possible that nominal court posts also imposed obligations on court

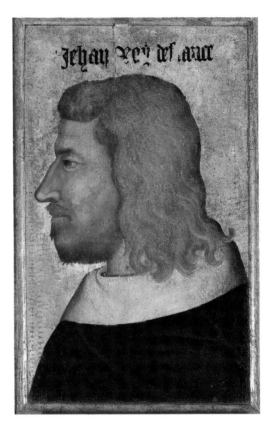

11 Portrait of the French King Jean II (*d*.1364), *c*.1350–60. Jean retained a painter, Girard d'Orleans, in his service as *valet de chambre*. Girard remained with Jean even during his captivity in England.

artists without the deterrent effect of formal contractual agreements.

Another source which again reflects the growing bureaucratisation of medieval society is the will, by its very nature a socially selective type of document and one very uncommon before the thirteenth century. Medieval wills pinpoint more accurately than anything else the social standing of individuals. The will (dated 1361) of one of King Edward III's painters, Hugh Peyntour of St Albans, who was buried at St Giles Cripplegate, London, includes the following:

I bequeath my whole mansion-house in which I live to Agnes my wife . . . I bequeath to my said wife all the silver and bronze vessels, the beds and all utensils and necessaries in any way belonging to my hall, chamber and kitchen, and forty pounds. Also I will that all my equipment with divers colours competent for my art shall be wholly sold and the money thence arising be

12 Fragments of the murals of *c*.1350–60 formerly in St Stephen's Chapel, Westminster, upon which Hugh of St Albans collaborated. Telling the story of Job, the inscriptions are an unusually prominent feature in such wall paintings.

distributed to the poor where the greatest need shall be for the benefit of my soul ... to the painter's light in St Mary's Chapel [at St Giles'] 10s. ... to Letice de Weston of St Albans 10s. ... to each of my two sub-executors 100s. also to each of them one bacinet with one aventail [a helmet with attached mail hood], also I will that all my other armour should be sold ...

... Also I bequeath to Agnes my wife for her maintenance, and that of my children, a six-piece Lombard panel painting which cost me £20 when still unfinished and lacking a frame and other items ...

... Also I will that my three belts garnished with gold should be sold ...

This document also includes numerous charitable donations to, among others, various hermits and anchoresses in London, pilgrims to Canterbury and Walsingham and also the bequest of a gilt processional cross. The most conspicuous (because unusual) item in the will is Hugh's possession of an Italian painted altarpiece in six parts, a polyptych. We do not know whether it served some devotional purpose (although no chapel is mentioned in the will) or whether Hugh obtained it to learn some new Italian tricks of the trade that appear to have been influencing other painters in this period.

The latter is likely, because the painters in Hugh's workshop who worked on the king's chapel of St Stephen at Westminster Palace in the 1350s are celebrated for their knowledge of recent Italian painting styles. In any event, Hugh's business was eventually closed down since his tools were sold off.

What strikes us about the will generally is Hugh's relative wealth. He owned a substantial property, since his will mentions a 'mansion-house' with hall and chamber, attributes only of the larger houses of the well-to-do. He owned a silver processional cross and lavish belts. Most importantly, Hugh emerges as a perfectly conventional citizen. He was called upon to perform military service, since he owned a helmet and other arms. This was not uncommon. In the mid-fourteenth century the painter's corporation of Ghent, in Flanders, could provide over forty men for the town militia, and their images were even painted in one of the local hospices. Earlier, in 1302, the Sienese painter Duccio had been in trouble for dodging local militia work. Hugh is concerned with the welfare of his soul, the support of his family, and adequate bequests for his church which included a chapel belonging to a painter's fraternity. Fundamentally similar but even grander is the will of Gilbert Prince, another royal painter who died in 1396. Like Hugh, Gilbert was buried at St Giles Cripplegate, and he also left charitable bequests to the religious folk of London. Unlike Hugh, Gilbert was something of a grandee. His will mentions a clerk, an apprentice and servants. His house seems to have had a chapel since he left his missal, chalice and vestments to St Giles. While Hugh left forty pounds to his wife, Gilbert left one hundred pounds over and above the household goods pertaining to his hall, chamber and kitchen. His business too was closed. The painter as Bohemian, elevating his subjective experience above worldly responsibilities, is several centuries away.

Some painters, especially those affiliated, like Hugh, to medieval courts, could do extremely well by reliance on a specific patron. Others could do extremely badly too, and there are examples in fifteenth-century France of court artists dying in debt. Most were more likely to find solidarity and security in a guild or a company. Guilds were an essential part of the late-medieval urban economy, existing partly to control quality and competition, and to offer a corporate response to fluctuations in the economy to which individual court patrons and artists were more vulnerable. They were generally strongest in large towns where factors of supply and demand were relatively stable. Often they were associated with a church or a saint which came to express their corporate identity; often (as Hugh's will shows) they were extremely charitable. In London, painters evidently gathered around a light at St Giles' church outside the city wall.

The patron saint of most painters, however, was St Luke, and his annual festival was marked by their celebration. St Luke was believed to

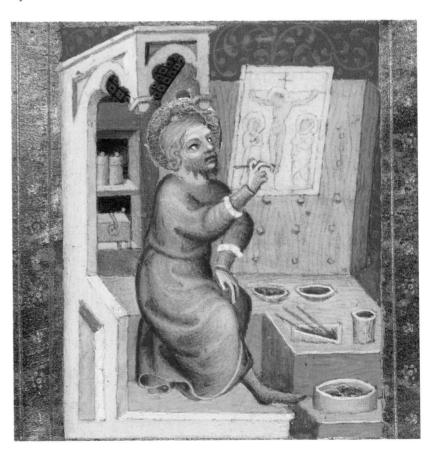

13 An early representation of St Luke as a painter, c.1360, executed in Bohemia in the *Gospel Book of John of Troppau*. Note the brush-rest, and the addition by St Luke of a thin undercoat to the panel sketch of the Crucifixion.

14 A peculiar development of the image of *The Man of Sorrows* (compare it with fig.**25**): Christ and the Trades, from a fifteenth-century manuscript. A hand holding a brush appears to the right of Christ's head, another holding a pen is in the top row of implements. Musical instruments and dice also figure.

images of Christ's tortures and redemptive death. Christ is shown as the vulnerable naked Saviour physically tormented by the tools used on Sundays by tradesfolk: scissors, saws, tongs, pincers, as well as by symbols of vice like playing-cards. Occasionally, paintbrushes are included (rather implausibly) amongst the implements poised ready for grinding into Christ's body.

The great period of the medieval painter's guild fell in the fourteenth and fifteenth centuries, a time when the craft of painting became increasingly differentiated from other trades. This was not yet the case in the twelfth and thirteenth centuries when, from surviving records, it appears that painters were quite likely to be affiliated to leatherworkers. The earliest statutes of the painters' guild in London, dating to the 1280s, contain several ordinances about saddle-making, for example. Late thirteenth-century Parisian tax records, which tell us much about the population of craftsmen in the city, use several terms for artists which imply increasingly fine distinctions. Three typical terms of the period are *peintre* (painter), *lumineur* (illuminator) and *ymagier* (usually sculptor). It was possible to be both a sculptor and painter: one such was Evrard d'Orléans, '*bourgeois de Paris*', who worked in the early fourteenth century. It was also possible to be a sculptor and an illuminator, like André Beauneveu, the late fourteenth-century French royal artist who was paid for both types of work.

But one important distinction does seem to have emerged at least by about 1300: painters were usually not illuminators. Painters cleaved to St Luke, whereas scribes and illuminators followed St John the Baptist. The 1391 statutes of the confraternity of St Luke in Paris only include painters and sculptors. Parisian illuminators already lived in their own quarter by 1300. The distinction seems to have sharpened in the twelfth and thirteenth centuries with a growing specialisation and fragmentation of activities typical of the medieval urban economy. In the first book of his early twelfth-century treatise, Theophilus moves smoothly from plastering to ink-making and book-painting, as if a craftsman could reasonably be

have portrayed the Virgin Mary in the flesh, and is sometimes depicted in the guise of a medieval painter with his various brushes and utensils. It was typical of late medieval crafts to take a saint as a prestigious protector and emblem (the goldsmiths' patron was St Eligius) and also as a guarantee, a placard, of honest practice. Painters in Italy could join companies formed for a fixed period, often three years, but guild membership was more permanent and inspired a different sense of loyalty, especially for lesser painters. The English medieval series of homilies called *Jacob's Well* exactly reflects this urban identification in distinguishing between the moral vices of urban craftsmen and rural labourers, peasants. Painters ('peyntourys') are thus grouped with smiths, weavers, brewers, thatchers, tailors, masons and plumbers, and not 'common labourerys'. The painter's identity as a craftsman was sometimes expressed more literally in a popular fifteenth-century painted image showing Christ and the Trades. This was an admonition to all craftsmen, including painters, not to work on the Sabbath, and it reflected the development in painting and sculpture of grisly

15 Painter and illuminator working side-by-side in the *Reuner Musterbuch*, early thirteenth century; the scribe wields pen and knife (for corrections), while the painter executes an image of May. Above, a figure holds implements used to grind colours. Such close association ended in the Gothic period.

but still used valuable materials like gold, silver and lapis lazuli in greater quantities than illuminators. In medieval York the painters, stainers and goldbeaters all belonged to one guild. In 1447 the painters' guild of Bruges prohibited illuminators from using any colours other than water colours: only the painters could use oil. On the other hand some of the skills required by painting and illuminating obviously overlapped, and for this reason, especially in fifteenth-century Flanders where both industries flourished, controls were imposed upon the movements of painters and paintings to maintain the separateness of the two crafts. To practise both illuminating and painting required membership of both of the corresponding guilds.

WORKSHOPS AND TRAINING

Owing to the considerable range of skills expected of painters, they also underwent longer training than illuminators: the fourteenth-century ordinances of the Tournai corporation of St Luke show that, while illuminators received two years of training, painters underwent four. Late medieval training was based squarely upon the apprenticeship system. This was closely tied to the family structure of the medieval town, since boys would usually be signed up with a master painter by their fathers. The usual age for apprenticeship, given local variations, was 15 to 25, and the length of training varied from four to eight years or more. Here is part of a contract of apprenticeship made in Zaragoza in 1486:

[I] Luis de Pancorbo, tapestry-maker . . . affirm and place as serving boy [*mozo*] and apprentice in the trade of painting my son Luisito de Pancorbo, present here, with the honourable Bartolome Valles, painter . . . for a period of six years . . . and that the said master Bartholome Valles is to give to the said boy during the said time food and drink, clothing and shoes . . . and show him the said trade of painting.

It was normal to call an apprentice a servant, a *garçon*; boys worked around the house and first learned the trade by doing the squalid (and potentially poisonous) tasks of grinding pigments and making glue. They eventually qualified as master painters by presenting a work, a 'masterpiece', to their company or guild.

expected to do both. But by the fifteenth century in Spain there were subdivisions even within the craft of painting, since in Andalusia there were specialised categories of altarpiece painters, fabric painters and interior decorators. In England the same processes which led slowly to the formation of the painters' and stainers' companies were also leading to the practical association of limners (illuminators) and scriveners (scribes).

From the Parisian documents it seems that painters had greater taxable wealth than illuminators. This is to be expected, since the wealth of a craftsman and his corporation was related to the value of the materials he used. Medieval trade hierarchies were arranged not just horizontally, with each craft broken increasingly into different branches, but also vertically, in terms of prestige. Goldsmiths used the most valuable and least easily-substituted material, had the largest reserves of capital and possessed the most socially distinguished and powerful guild. Mayors were commonly chosen from the ranks of the goldsmiths. Painters were appreciably lower down the scale of guild status

Mastership, the title of *magister*, meant independence, authority and the ability to teach the trade to others; it corresponded to the degree of M.A. in a university. It also had obvious economic advantages. The following extracts from documents recording the wages of painters employed at Westminster Palace in the 1290s and 1300s illustrate the hierarchical wage-structure, common throughout much of Europe, of a medieval workshop starting with its *magister*:

Roll of expenses and outlays made by the hand of Master Walter of Durham concerning the emendation of the paintings in the king's great chamber begun 28th April in the 20th regnal year of King Edward [1292] ...

In the wages of Walter for one week,
12d a day sum 7s
In the wages of Curteys for one day 6d sum 6d
To Richard of Stockwell for one day 6d sum 6d
To Alexander of Windsor for 5 days,
6d a day sum 2s 6d
To Richard of Bridiz for the same time sum 2s 6d
To Thomas of Tickhill for the same time,
$4\frac{1}{2}$d a day sum 1s $10\frac{1}{2}$d

and from a 1308 account, to complete the staff:

To William Wyt, grinder, 2d
To John of Norfolk, servant, 1d

One can infer from the wage-structure of the medieval atelier that the master was responsible for establishing the overall design of the work, including the style and quality of its drawing. Materials preparation, and the bulk of the painting, was conducted by the assistants. Such documents reveal much about the social structure of a medieval workshop: the names are often toponymics, indicating place of origin; painters came and went for different periods according to need (the master always had to be present, however); and there is a clear wage discrepancy between the master and his assistants. In the late thirteenth and fourteenth centuries it was normal for a master painter to earn a shilling a day, a wage roughly one quarter of that commanded by a royal goldsmith; the servant's wages were those of a labourer. Workshops of this type were also extremely variable in size. The basic unit of master painter and assistant could be swelled by as many as

twenty or thirty other painters, depending upon the size of the undertaking; wall-painting workshops were usually larger than those for panel painting.

What people are called in documents is often a guide of sorts to contemporary practice; valuable, but uneven, is the evidence of paintings themselves. 'Signatures' in this period were usually just formal inscriptions naming the master whose shop produced the painting. Before the fifteenth century such 'signatures' are quite common in Italy. Their almost total absence from paintings in northern Europe has not been explained. It cannot demonstrate the lack of workshop hierarchy or literary tradition, since scribes and illuminators quite often name themselves in manuscripts, and architects' names were also commemorated in the north. As we have seen, there was also a literary tradition in northern manuscripts of depicting great artists at work.

Early Italian painters' inscriptions, like that naming three related Roman painters beneath a twelfth-century mural at Sant'Anastasio at Castel Sant'Elia at Nepi, are similar to monumental carved inscriptions on Italian medieval sculpture:

JOHANNES ET STEPHANUS FRATRES PICTORES ROMANI ET NICHOLAUS NEPOS VERO JOHANNIS [brothers John and Stephen, painters of Rome, and Nicholas, nephew of John]

Other inscriptions, such as the rhyming example below which appears on a Sienese Virgin and Child of *c*.1280, are basically prayers for the painter. The Sienese inscription embodies the contradictory impulse to promote the artist's name while also humbly seeking expiation for him. We should note that the 'voice' of the signature is not that of the painter, but rather that of the person represented by the image, the Virgin Mary, who traditionally interceded with Christ on behalf of mankind:

ME GUIDO DE SENIS DIEBUS DEPINXIT AMENIS: QUEM CHRISTUS 16
LENIS NULLIS VELIT ANGERE PENIS ANO.D. MCCXXI [Guido da Siena painted me in the delectable days, whom may gentle Christ torment with no punishments 1221 AD]

Texts of this type are not straightforward evidence for attribution, since medieval pro-

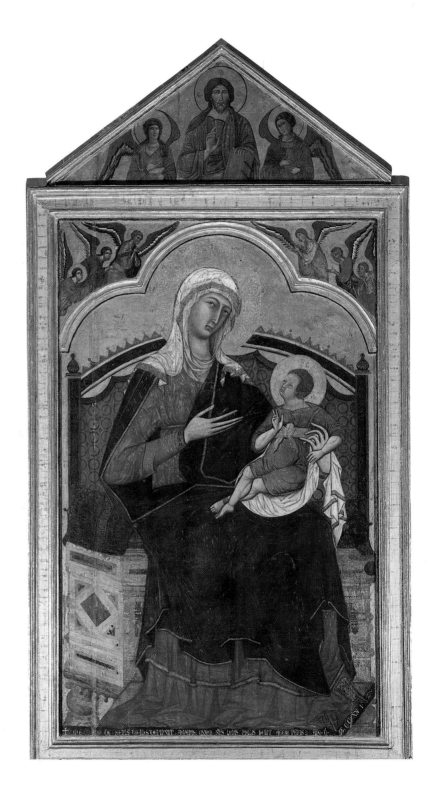

16 Madonna with Child, Guido da Siena, c.1280; the inscription mentioning Guido is immediately beneath the Virgin's feet.

duction, though guided by a *magister*, was collaborative. What they do is advertise the hierarchy of the workshop responsible. A number of panels retain Giotto's 'signature': the Bologna polyptych bears the text 'Op[us] Magistri Iocti de Florentia' (the work of master Giotto of Florence), for example. But on close examination the panel appears to have been made in Giotto's businesslike workshop – a 'Giotto product' – in which the hands of the various assistants who did much of the work were conceived of as extensions of the master's own hand.

PAINTING, CRAFT AND ART
By the fourteenth century the trade name 'Peyntur', as borne by Hugh of St Albans, was common. A painter would inherit it much as he inherited his tools, his status and his skill: painting, like illuminating, was often a long-standing family concern. This was certainly true within the guild structure, which could exempt members of painter families from apprentices' examinations. It was also true of court employees, such as a family from Boulogne which served the counts of Artois throughout the fourteenth century in the bizarre-sounding inherited post of *maître des engins et des peintures* (master of the engines and paintings), or the Orleans family which served the French monarchy throughout the same period. Earlier, in the twelfth century, Theophilus' treatise gave a biblical context for the idea of inherited skill and so universalised it: according to Theophilus, when God created the world and man, He breathed into man the ability to participate in the wisdom (*sapientia*) and artifice (*ingenium*) of the Divine Intelligence, an ability passed on to Adam's successors after the Fall. Whosoever is diligent will be able, through man's natural activity, labour, to participate 'as if by hereditary right'; he who does not is merely foolish, disobedient like Adam. Twelfth-century Parisian thinkers like Hugh of St Victor regarded *ingenium* as a natural force requiring the constraints of practice and discipline. The idea seems to have been fairly common even on the peripheries of Europe: God 'the first of masters, the best craftsman and the source of all the arts in the world' is invoked in a thirteenth-century letter from an Icelandic painter giving instructions about panel painting to a monk. Ultimately, only God could be the source of true creativity.

Cennino Cennini, writing in the tradition of Giotto's Florentine workshop, also opens his treatise with God's creation of the world, mankind's fall and his assumption of labour as his natural activity. But Cennino's idea of the way skill is passed on is much more that of the urban workshop tradition, since he pays homage to his teacher, Agnolo Gaddi, and ultimately to the founder of his tradition, Giotto himself. Inheritance of skill is thus viewed within the framework of the master-pupil relationship predominant in the medieval workshop.

The basis of medieval notions of creativity was provided by the idea of artifice. By its nature, this idea stressed the importance of versatility in the handling of materials. The fourteenth-century title of *maître des engins et des peintures*, held variously by Jacques, Laurent and Hugh de Boulogne at the château of Hesdin in Artois in the fourteenth century, although eccentric, exactly reflects the importance which then attached to artifice. The '*engins*' in question seem to have been a set of mechanical contraptions for the entertainment of the Counts of Artois, which shot water, soot and flour at unsuspecting courtiers, set statues moving, dropped people down trapdoors and generally incommoded the passers-by. One particular painter was still in charge of these fairground follies at the end of the fourteenth century: Melchior Broederlam of Ypres, a Fleming who[17] worked in the service of the Dukes of Burgundy as '*varlet de chambre*', master of the engines, painter, textile decorator and even designer of tiled floors. His surviving work – the wings painted for a carved wooden altarpiece in the Chartreuse at Champmol, patronised by the Dukes of Burgundy who were among the greatest patrons of their age – is now regarded as an important ancestor of Netherlandish art.

Melchior's contemporaries would have seen nothing incongruous in his range of skills. As we saw earlier, medieval culture haphazardly preserved older, antique, literary traditions which

17 The Annunciation, from Melchior Broederlam's painted wings for the carved altarpiece of the Charterhouse at Champmol, Dijon, 1390s. The paintings were executed in Ypres. Note the tiled floors: Melchior was responsible among other things for 'ordonnance de carrelages', that is, planning tiled pavements.

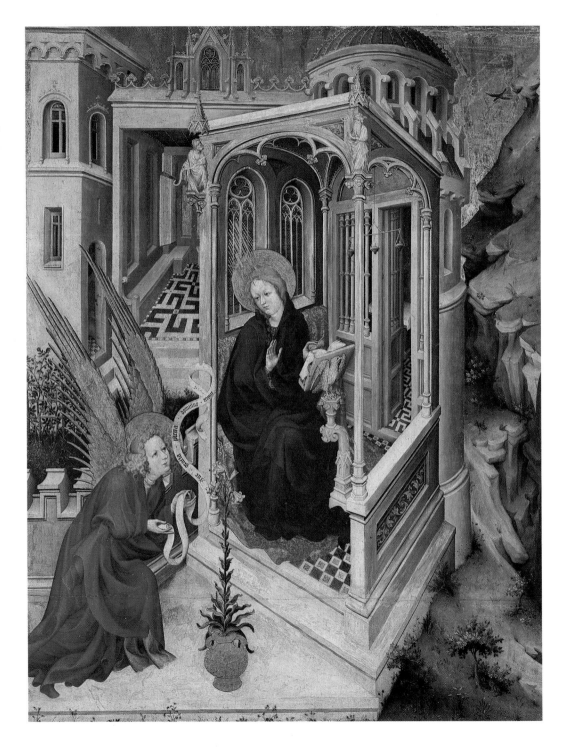

elevated universal competence in artists. However, the discriminating language of classical authorities was blurred by medieval writers, who were appreciably sloppier than their antique forebears and Renaissance successors in the way they formulated their perception of artists. An example is the medieval use of Ovid's phrase *opus superabat materiam* – the workmanship surpassed the materials (*Metamorphoses* II, 5). This phrase occurs frequently in medieval comments on art, and (contrary to its classical sense) often in connection with objects which were not intrinsically precious; in the Middle Ages it was used as a conventional, and none too precise, form of praise. It hinted at wonders of craftsmanship but, unlike the Italian Renaissance, usually regarded skill more as an ability to manipulate and overcome the limitations of materials, than to represent the perceived world accurately. Again, Theophilus used the word *ingenium*, artifice, with the implication that it could be inherited and developed by diligence. By the fifteenth century, Renaissance humanists would call this inherited skill *ars*. *Ingenium* was beginning to mean something like inspiration or genius, neither learned nor inherited. It was but a short step to argue that certain artists – such as Michaelangelo – received their *ingenium* directly from God and were therefore divinely gifted.

The painters' guilds of fifteenth-century northern Europe, under the banner of St Luke, guaranteed professional quality without making such ambitious theoretical claims for the abilities of their members. That is why medieval painting is often described as a craft, and Renaissance painting as an art. The distinction between art and craft is in many ways deeply prejudiced. It is the post-medieval relic of a time when Renaissance theorists attacked the Gothic style as the lawless, and so in their terms artless or irrational, product of barbarian Germans. It is also largely meaningless, since the methods used in making paintings did not change radically in fifteenth-century Renaissance Italy, and remained to all intents and purposes those of a craft recognisable anywhere in Europe. Yet it contains a grain of truth, because it acknowledges that while the process of painting remained stable in late medieval Europe, its intellectual and aesthetic foundations were to some extent changing.

Painting seems in any case to have gained in stature in the fourteenth and fifteenth centuries, partly because of the new social status of some painters, but also because the role of painters as designers of work executed in other media was acquiring an authority it had not previously possessed. This was especially true of northern European stained glass and textile design. The design of twelfth- and thirteenth-century stained glass is much more strongly influenced by metalwork than it is by painting, reflecting the theoretical priority of precious materials and so their gravitational 'pull' on other art forms in the Romanesque aesthetic. From the late thirteenth century onwards, however, Gothic stained glass shifts perceptibly in its sources [18] away from metalworking towards painting and architecture. By the fifteenth century the production of stained glass was increasingly divided between a designer and a maker. Significantly, the designer was likely to be a painter: Cennino states that glaziers 'possess more skill than draughtsmanship, and they are almost forced to turn, for help on the drawing, to someone who possesses finished craftsmanship, that is, to one of good all-round ability'. He meant, of course, a painter.

The same division of art creation into design and manufacture is witnessed in Gothic textile design; for example, the magnificent later fourteenth-century Angers Apocalypse tapestries [19] were designed by a French royal painter, Jean Bondol, but made by a Parisian weaver, Nicholas de Bataille.

The practical role of the greatest painters was thus demonstrably a large and growing one, but there is no reason to suppose that it was based on theoretical foundations. In Italy, on the other hand, a different method of assessing the role of the painter was emerging by the late fourteenth century. Cennino's stress on the universal validity of the skill of drawing as the basis of design, in many ways fully medieval in origin, also had classical precedents. Growing importance was now being attached to designs as the special property of painters. Architects were also producing more magnificently-finished

18 The Annunciation depicted in stained glass in the south aisle of nave of York Minster, *c.*1340. The composition is of a type developed exclusively in the circle of the Sienese panel painter Duccio about thirty years earlier, the ancestor of the composition shown in fig.**17**.

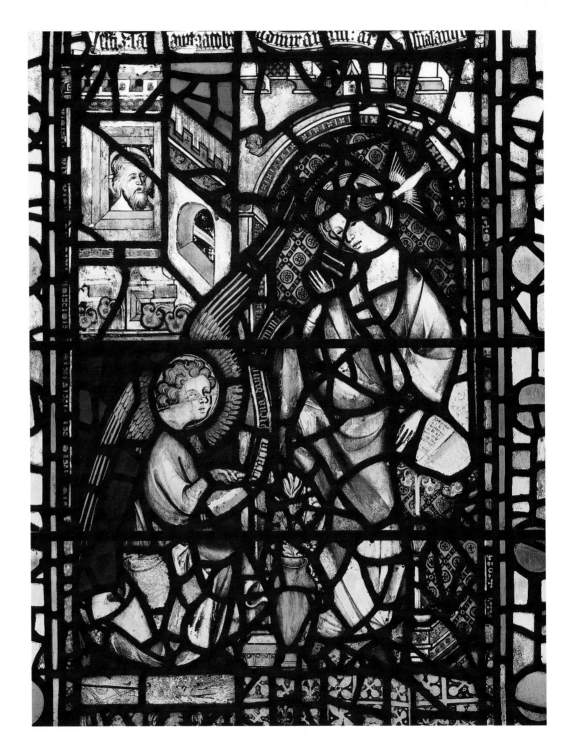

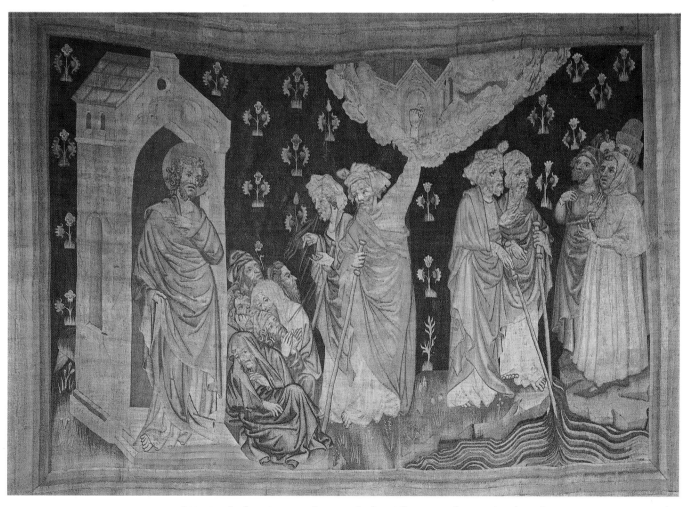

19 The Witnesses, from the Angers Apocalypse tapestries made for Louis I, Duke of Anjou. Woven in the 1370s in Paris using cartoons of Jean Bondol, painter to Louis' brother Charles V of France; Jean is known in turn to have studied an illuminated Apocalypse manuscript for his designs.

architectural drawings, unknown before the thirteenth century. The way was increasingly open to a more purely intellectual apprehension of design, and of its theoretical grasp and learnedness. Northern European painters never attracted the praise that they were learned; their world view, channelled by the guild emphasis on sound practice, was concerned more with the moral than with the theoretical attributes of the artist. Learnedness was rather (as in thirteenth-century Paris) the attribute of the architect or mason who dealt with practical geometry. Geometry was one of the so-called liberal arts and a part of the university curriculum. Those who understood and used it were not just masters but also *doctus*, learned. The notion of the learned painter, however, was almost exclusively of Italian currency. By the fifteenth century, in the great commentaries of Ghiberti on the artistic founders of the Italian Renaissance such as Giotto, we often read that a painter was *dottissimo*, most learned. This obviously carried a significance over and above the implication that such a painter paid attention to his craft's regulations and produced durable work. It implied a certain intellectual stature. And it was in the fifteenth century, too, that Italian contracts for paintings increasingly emphasised not

the expense of the materials used in their manufacture, but rather the importance of the skill of the painter in representing things as they appeared in nature.

In the fifteenth century there was also a literary tendency, amongst Italian theorists such as L. B. Alberti, to elevate painting fully to the level of a liberal art, like rhetoric. This was a social as well as an intellectual distinction; it was known that the liberal arts in the antique world were practised by freemen, but the mechanical arts were restricted to slaves. Since, according to this view, the Greeks were thought to have excluded slaves from painting, literary and historical tradition placed painting nearer the liberal than the mechanical arts. Painting was an appropriate activity for the high-born. Cennino comments that panel painting enabled a man to wear velvet on his back, implying not only his relative wealth but also his lack of the rude mechanic's sweat. In saying this, he is to some extent striking an intellectual pose, just as when he says that the student painter should arrange his life as if he were studying theology, philosophy or 'other theories'. But his pose was influential, since its stress on the intellectual rather than practical foundations of art became more widespread, paving the way for some of the prejudices of modern art history. Our first step in understanding the medieval painter is to be aware of those prejudices. Our second is to look at his work.

20 Painting as a Liberal Art, sculpted relief from the Campanile of Florence Cathedral, late 1330s. The painter leans forward on a small stool and peers at the ancona while working on it.

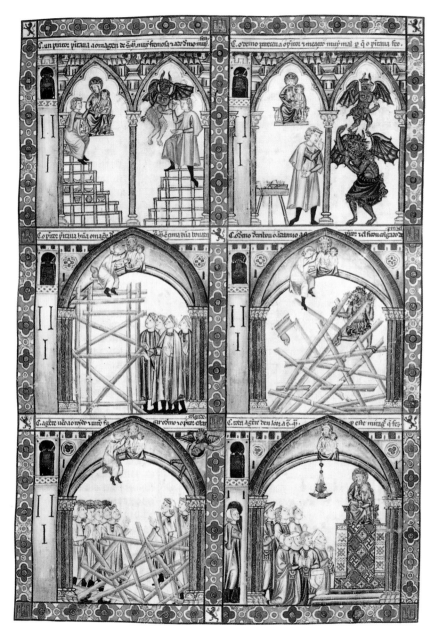

21 How the Virgin Mary saved a painter from falling: a stage-by-stage narrative from *Las Cantigas* of Alphonso the Wise, late thirteenth century. Note the use of the scaffold to hold utensils.

2 THE PRODUCT

THE HOLY AND THE UNHOLY

In a late thirteenth-century manuscript of the Castilian *Cantigas* of King Alphonso the Wise, containing hundreds of songs about the Virgin Mary, we are entertained and edified (although perhaps not impelled to devotion as intended) by the story of the painter who executed on a vault a beautiful image of the Virgin and, next to it, an ugly one of the devil. The devil, ever vain, threatened the painter, but he continued his pious work, so the devil brought him and his scaffolding tumbling down. With the Virgin's intervention, however, the painter literally adhered to the image he was making and was thus saved from the fall, to the amazement of the people.

The painter kept interesting company. The fourteenth-century marginal illustrations in the so-called Smithfield *Decretals* (a compilation of Roman law) include a painter, perched on a ladder while colouring a roadside statue of the Virgin Mary who tramples on a demon. A large devil, understandably offended by the image's content, argues with the painter by striking a lawyer's pose and exclaiming in doggerel legal Latin 'I deny ... therefore'. In the next illustration, he breaks the painter's ladder, but, as in the story in the Castilian *Cantigas*, the image saves the painter's life. The painter, by the act of colouring a statue, and so bringing its mutely sculpted surfaces to life in defiance of the demon, is almost engaged in a form of advocacy.

Such illustrations encapsulate the wider, and more consequential, medieval belief in the importance of images, especially those of Christ, the Virgin and the saints. Those holy personages represented by the images could intervene in the affairs of the world and in the spiritual salvation of mankind. In the thirteenth century, a painted crucifix once spoke to St Francis, and accounts of miraculous paintings and sculptures are common. Frequently in the Middle Ages we meet the idea of the proximity of the painter to the sacred. The Virgin Mary intercedes for the painter Guido in the 'signature' on his painted

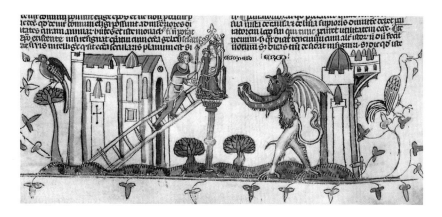

22 A painter perched on a ladder colours a roadside image of the Virgin Mary; a devil protests. From the Smithfield *Decretals*, *c.*1340.

23 Painting commemorates ceremony: a thirteenth-century consecration cross.

Madonna, which we quoted earlier (see p.17). Cennino Cennini invokes the Holy Trinity and the Virgin Mary before describing the methods of painting. In the last chapter we saw that painters took as their patron St Luke, who had reputedly portrayed the Virgin Mary in person. St Luke exemplified their craft.

The painter, through his craft practices and production, engaged in the wider Christian struggle for spiritual good. He was forbidden to work on a Sunday for fear of wounding Christ anew. He had been involved indirectly in the process of conversion to Christianity, and so of evangelisation. Bede, in his account of the conversion of the English, tells us that in 597 St Augustine and his missionary monks approached the pagan King Ethelbert (who was so suspicious of their magic that he would only meet them out of doors) 'carrying a silver cross as their standard and the likeness of our Lord and Saviour painted on a board', i.e. a Roman icon of Christ. Later on, the painter's concern was more prosaically related to the transmission of the Church's system of belief to the con-

verted. But it never lost what might loosely be called a magical function. The painter made the holy manifest and corporeal, since in many cultures to complete an image with colour is a means of empowering it.

In 1238 the Bishop of Lincoln, Robert Grosseteste, directed that:

> altar stones should be respectable and of suitable size, firmly fixed in a wooden frame so that they cannot be moved from it, nor usurped for any uses other than the celebration of the Divine Office. Obviously colours should not be ground on them, nor should they be used for other similar purposes.

Robert's concern about the misuse of altars by painters is in a sense unsurprising: what else would a churchman say about behaviour at the altar which symbolised Christ? Painters, laymen, were admitted to the priest's preserve to execute sacred art, not to exploit the smooth surface of the altar-stone. Robert perfectly exemplifies an attitude towards the altar and the Mass typical of the later Middle Ages. From the thirteenth century the doctrine of Transubstantiation, which held that at Mass the priest's consecration converted the bread and wine into the actual body and blood of Christ, was official church doctrine. By tempering colours on the smooth flat stone surface required on an altar by canon law, painters dishonoured Christ's body; the altar was Christ and Christ manifested himself upon it. Through his work, the painter approached what was holy, either by creating superbly gripping images of Christ's Passion, or 25 by physically working in the Holy of Holies in church and adding to it a wall painting or consecration cross. 23

The medieval painter's importance cannot be understood independently of his works; without the products, the history of the painter is just another social history of a craft. Painters visualised and represented the highest truths of medieval Christendom. Yet their craft was immensely versatile. Their strategy combined what in medieval English parlance was called *lust* and *lore*, i.e. pleasure and instruction, equal priorities in church and residence. The demand for painting registered widely throughout society. The fourteenth-century Dominican preacher, John Bromyard, refers in his moral

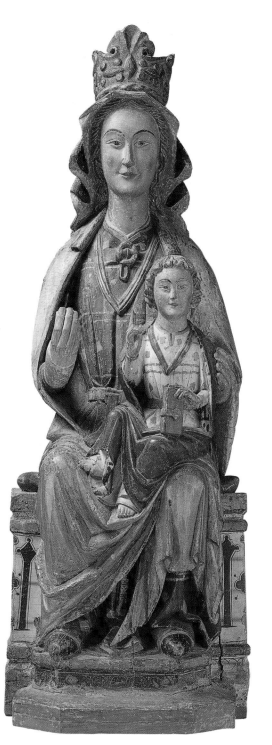

24 A late thirteenth century Spanish image of the Virgin and Child with original colouring, similar to that shown in *Las Cantigas*. By this time most churches were expected to have at least one image of the Virgin Mary. Beneath her feet are two diminutive tonsured figures (compare with fig.**4**).

portrayals of the world to coloured inn signs, smoke from fires disfiguring and blackening the rude paintings on ordinary house walls, and the royal banqueting hall with its painted figures. Painted shop and pub signs can be seen in many 26 later medieval depictions of street life. Roadside images of the Virgin Mary, as we see in the Smithfield *Decretals*, were commonplace. The painter who ground his colours in the parish church also enlivened the local pub. In 1430–1 the Boar's Head Inn on King Street, Westminster, had interiors lustily painted with 8s. 4d. worth of red lead worked with oil and size, spattered with gilt motifs provided by four dozen stencils and gold dust, 16d. per stencil. Red rooms were later noted in the inn in 1479, anticipating the chichi of the nineteenth-century Victorian pub. For such work, many medieval cities – Paris, Norwich and Ghent, for example – had substantial reserves of painters at their disposal and, as far as we know, very similar techniques were used in decorating religious and secular buildings.

A tiny fraction of the work of medieval panel and wall painters actually survives. In Europe, and especially in Italy, the majority of wall paintings survives in churches. This is also true of Protestant states in northern Europe, despite the fact that much Catholic imagery, especially of the saints, was wiped out during the Reformation in the sixteenth and seventeenth centuries, often with ruthless efficiency. Many surviving medieval paintings bear evidence of later indifference or downright hostility. Panel 27 paintings fared badly. In the case of Italy, which still preserves the majority of medieval panel paintings, it has been estimated that the ostensibly abundant survival of about 600 panels dating to before 1300 represents well under five per cent of the total original production. Panel paintings of any type seldom pre-date the thirteenth century, and Romanesque wall painting (roughly of the period before 1200) is easily surpassed in quantity, although not always in quality, in the Gothic period. Since medieval inventories tend to record only objects of intrinsic worth such as jewellery or plate, paintings, which often had virtually no intrinsic value, are also grossly underrepresented in

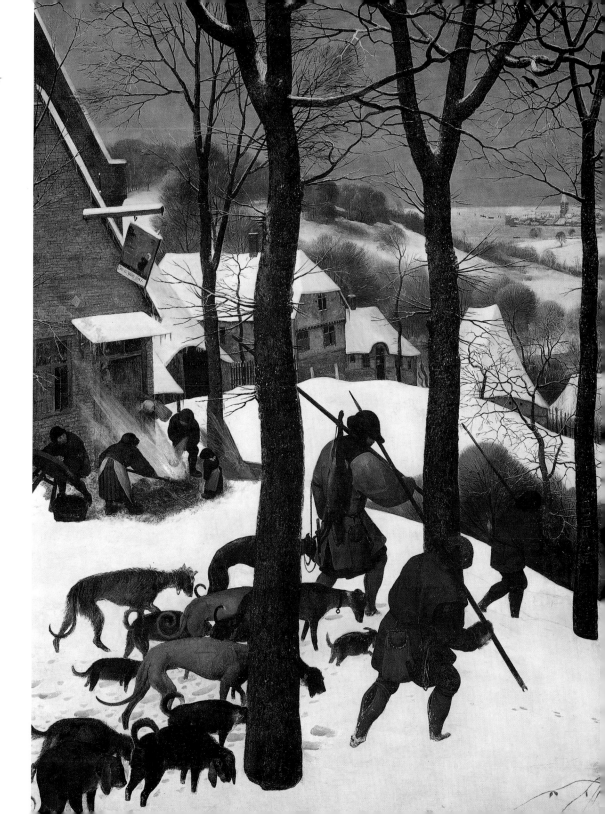

26 A painted placard dangles perilously from a house in Pieter Bruegel's *Hunters in the Snow* (1565).

27 Censoring the hierarchy of heaven: post-Reformation vandalism often targets the faces of images in order to disempower them. An angel from the fifteenth-century rood screen at Southwold, Suffolk.

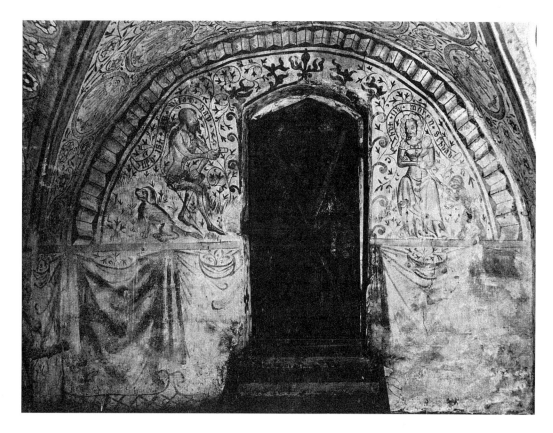

28 Fourteenth-century murals with vernacular German inscriptions to either side of a doorway in the Ehingerhof, Ulm. The curtain on the dado is typical of medieval painted decoration.

written records. Residential buildings, unlike churches, were the first to become obsolete and so the first to be replaced. Painted domestic interiors in castles, palaces or houses accordingly survive even less often than the buildings themselves, despite the likelihood that they must have been the most important repository of the painter's craft, especially in cities. Seldom can we appreciate the overwhelming impact of painting upon the medieval domestic interior, as in fourteenth-century painted rooms in the German city of Ulm, or at Longthorpe Tower in England. Paintings have slipped through the net with extraordinary ease.

The range of documented but destroyed domestic painted decoration was immense. For example, in northern Europe between the ninth and sixteenth centuries, there was a long tradition of decorating major rooms in residences with pleasure-giving stories, often of an heroic, exemplary and preferably violent type based on the Bible, romances or classical and dynastic history: such stories decorated at least one palace of the Carolingian emperors in the ninth century, at Ingleheim, and were also found in the thirteenth-century Palace of Westminster. Very few such schemes now survive. Patrons also liked their chambers to be coloured green, green being regarded as a health-giving and fertile colour: green chambers were found in the thirteenth-century Louvre in Paris, and Pope Clement VI commissioned stunning painted woodlands and gardens for his private *chambre du cerf* in the papal palace at Avignon, in the mid-fourteenth century. Almost any image could be found in a residence.

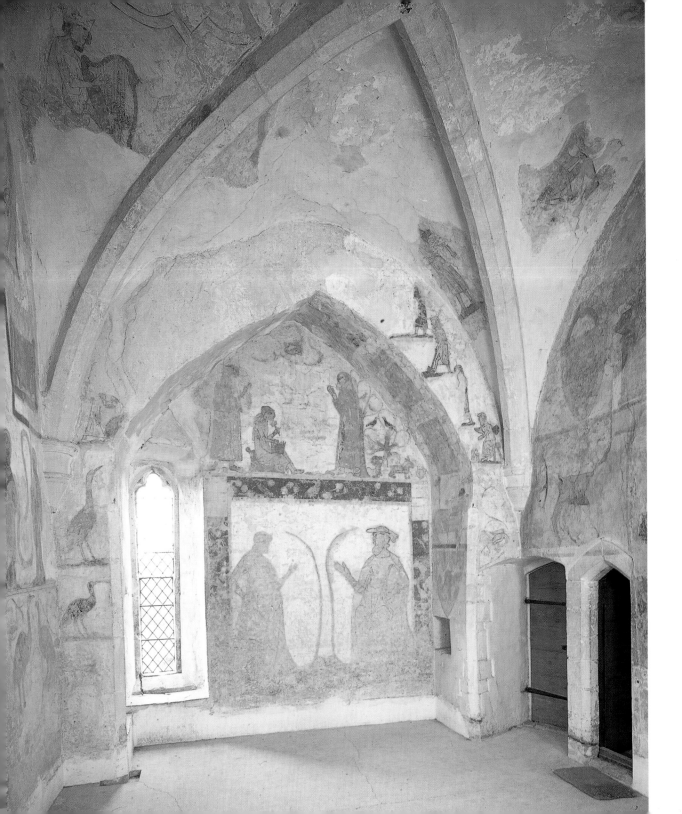

29 *Opposite* Murals of *c.*1330 in Longthorpe Tower, Northamptonshire. Depicting a variety of moralising subjects, the murals form a 'spiritual encyclopaedia' for lay appreciation and improvement.

30 *Below* The *chambre du cerf* of Pope Clement VI, in the papal palace at Avignon, mid fourteenth century. Like Longthorpe Tower the images are encyclopaedic, but here the subject matter – methods of hunting and fishing – is purely profane.

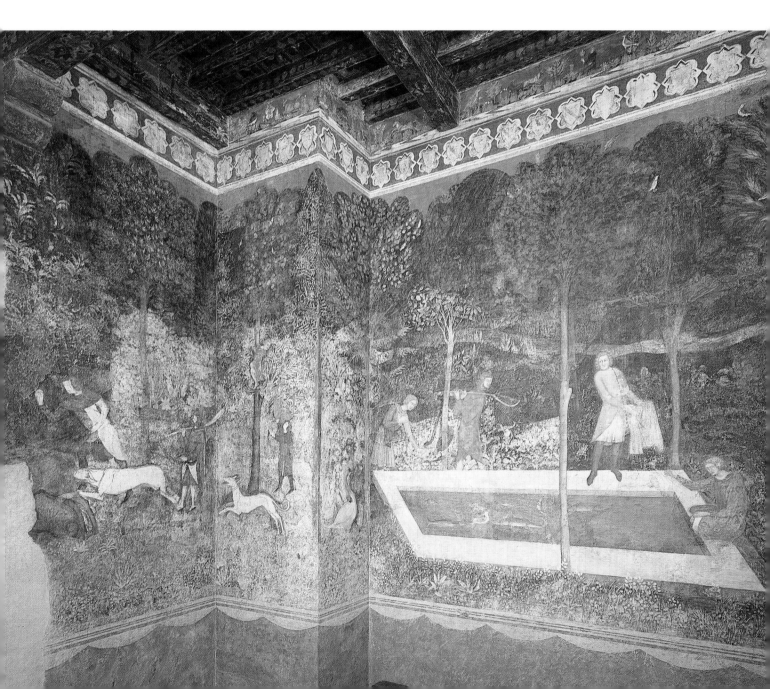

CONTROLLING AND UNDERSTANDING IMAGES

All of this raises the question of how the painter's work was controlled. In domestic painting, tradition and the patron's wealth and whim shaped decorative taste. Medium and style – tapestry and painting seem to have been largely interchangeable – were of secondary importance to entertainment value and the principle that interiors should either be comfortable-looking or ostentatious, depending on their function. The controls at work thus differed somewhat from those of religious painting. They were social and aesthetic, not doctrinal.

Medieval religious *lore*, as opposed to secular *lust*, had its own traditions and decorum, although in many ways these were not as strict as those later promulgated by the Catholic Church in the course of the sixteenth-century Counter-Reformation. There was little artistic legislation in the Middle Ages. Some types of medieval church art required no control at all. Exterior polychromy was a normal part of the appearance of a great church geared to public display: the great sculpted west façade of Wells Cathedral was brightened with oil-based pigments, and sculpture was no less illuminated at Lausanne Cathedral. Most medieval regulations were concerned simply with proper altar-fittings and the need for even the lowliest churches to be equipped with decent coloured images of the Virgin Mary and the saints. Surviving thirteenth- and fourteenth-century documents of the visitations made to country churches by Church authorities often reveal the grim reality of the medieval religious environment: churches lacking roofs and glazed windows, not being properly dedicated to a saint, and containing images *male depicta* – badly or inaccurately painted (for example, giving the patron saint the wrong attribute).

Control took other forms. Since the role of the artist was traditionally viewed as an instrumental one, creative initiatives lay rather with the patron and adviser. In ecclesiastical cases, the nature of patronage varied widely according to whether the institution was a monastery, a cathedral or an urban church under

31 The thirteenth-century sculpted portal at Lausanne Cathedral retains extensive traces of its delicate original coloration.

the control of a corporation; but it was here, with small groups of people or individuals, that power lay in the first instance, either with respect to dictating the content of a painting, or to providing the materials with which it was to be made. Control could mean regulating the way painters behaved, as in the example of Bishop Grosseteste's strictures on grinding colours on altars mentioned earlier (see p.26). It could also take the form, in more prejudiced cases, of polemical writing against some sorts of painted image. Occasionally we read of images

which deviated in various ways from custom and hence were criticised as heretical: one case is the attack by Lucas of Tuy on three-nail Crucifixions (with one nail, not two, through the feet of Christ), a twelfth-century innovation which was regarded as subversive of the meaning of a central holy image. In attacking heretical images, Lucas refers more than once to the 'wickedly presumptuous painter' and painters 'seduced by wanton temptation'.

Cennino Cennini, at the beginning of his handbook, writes of the painter's revelation of things not seen; to this he adds the painter's poetical freedom through artifice to compose figures 'standing, seated, half-man, half-horse . . . according to his imagination'. Earlier, around 1200, a monastic author, probably representing the views of the puritanical Cistercian order of monks, launched into an attack on this licence of painters in a treatise called *Pictor in Carmine* ('The Painter in Poetry'). He excoriated 'foolish pictures' and 'meaningless paintings in churches, especially in cathedral and parish churches', and seems to have been referring especially to the sorts of grotesque creatures often found in the margins of medieval art, since he writes of 'double-headed eagles, four lions with one and the same head . . . headless men grinning' and so on. Notably he attributes the presence of these 'sports of fancy' to 'the criminal presumption of painters', and attempts to 'curb the license of painters' with lengthy proposals as to what churches should have in them instead, especially stories from the Old and New Testaments.

The concerns of Lucas of Tuy and *Pictor in Carmine* are those of a period in which the Church was making widespread efforts to codify and authorise Christian belief as a whole. It was considered necessary to purge Christian subject-matter of heretical and secular, even pagan, profanities. When *Pictor in Carmine* complains of monstrosities depicted 'about the altar of God', its author is demonstrating fundamentally the same reforming anxieties as Bishop Grosseteste of Lincoln. Nevertheless, the widespread drive to clarify doctrine and educate laypeople (if not convert them) typical of the thirteenth-century Church required good, clear, educative art. The painter, although

always at risk of failing to balance artifice and invention with the legitimate image, was still needed.

This statement by the Franciscan St Bonaventure (*d.*1274) is representative of the contemporary outlook:

1. [Images] were made for the simplicity of the ignorant, so that the uneducated who are unable to read scripture can, through statues and paintings of this kind, read about the sacraments of our faith in, as it were, more open scriptures.

2. They were introduced because of the sluggishness of the affections, so that men who are not aroused to devotion when they hear with the ear about those things which Christ has done for us, will at the least be inspired when they see the same things in figures present, as it were, to their bodily eyes. For our emotion is aroused more by what is seen than by what is heard.

3. They were introduced on account of the transitory nature of memory, because those things which are only heard fall into oblivion more easily than those things which are seen.

Bonaventure's calmly pedagogic outlook is concerned with yielding a smooth intellectual justification for the use of images primarily for laypeople. It was not original (its basic tenet, that images are a form of text for the illiterate,

32 Cistercian 'sports of fancy'. Early fourteenth-century grotesque beasts decorate the walls of the *capella ante portas* of the Cistercian Abbey of Hailes (Gloucestershire), contrary to the spirit of the text of *Pictor in Carmine*.

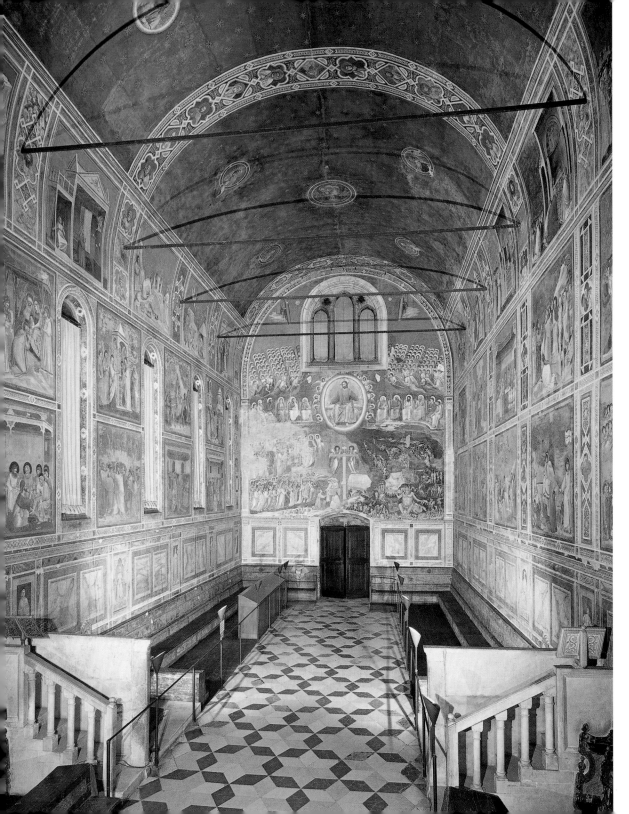

33 West view of the Arena Chapel, Padua, showing murals by Giotto, *c.*1305. Over the doorway is the Last Judgement, including the figure of Enrico Scrovegni, the donor (immediately over the door, to the left).

was first articulated by Pope Gregory the Great, 590–604), nor was it in any sense intended to guide painters. The sort of wall-painting scheme which would nonetheless exemplify it ideally is that executed about 1305 by Giotto in the Arena Chapel in Padua which, for all its extraordinary artfulness, is scriptural, moving and memorable. The Arena Chapel was painted for a wealthy lay patron, Enrico Scrovegni, whom Giotto portrays on the side of the Saved in the chapel's Last Judgement fresco. In 1304 the Pope issued a bull granting indulgences to those visiting the Arena Chapel. In addition to being moved and informed by its paintings, visitors were therefore also granted something specific: one year and forty days off their due time in Purgatory. The paintings were part of what has been described as the medieval obsession with 'strategies for the afterlife'.

What one actually saw at Padua's Arena Chapel was fundamentally no different in its content and aims from the sort of murals surviving today in the parish church of Chalgrove in England, murals done at almost exactly the same time as Giotto's, but in a different technique and style and occupying a very different place in art history. In both buildings, the stories are those of the life of the Virgin Mary and Christ. The material illustrated is drawn not only from the official New Testament but also from uncanonical, widely-used and officially sanctioned, apocryphal sources which served to flesh out the Gospel account at those points where laymen required more information – as for example the life of the Virgin Mary, about whom the canonical Gospels say virtually nothing.

The paintings at Padua and Chalgrove, though contemporary, demonstrate the immense differences in technical approach and aesthetic outlook of medieval painters, depending on the traditions to which they belonged. Yet, despite their dissimilarities, they witness to the existence of comparable expectations on the part of their audiences. We do not know who paid for the paintings at Chalgrove, but the

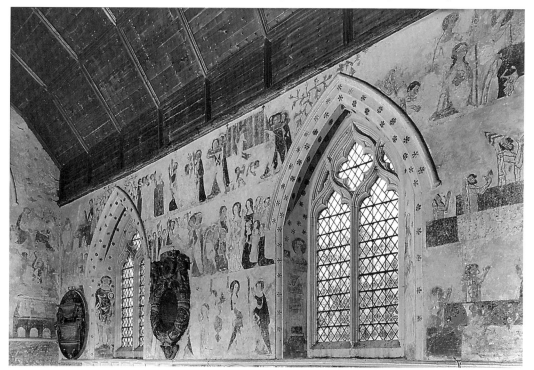

34 The life of the Virgin Mary and the Last Judgement (to the right of the picture) dominate the chancel of the parish church at Chalgrove, Oxfordshire, early fourteenth century.

likelihood is that the patron was a layman, like Enrico Scrovegni at Padua. At both places, lay influence in the choice and general formulation of the paintings was strong. That would be in keeping with a very general tendency in this period for the initiative in art patronage to be taken by the laity, something apparent in the increasingly common depiction of the patron actually in the images he commissioned (as at Padua), and in the growing evidence of lay commissions in contemporary contracts for paintings, about which more will be said later. The growth of lay control over the art of the painter in the Middle Ages is likely to have been a major factor in the creation of the wealth of painted images that typified late medieval church decoration, whether in Italy or in the northernmost parts of Europe. Individual and corporate piety of the type which brought murals and altarpieces into being must have been a major stimulus to the co-ordination of effects of paint, stained glass and coloured sculpture typical of the medieval church ensemble.

THE PAINTED ENSEMBLE

The wealth of images with which medieval churches were often stocked emphasises the extent to which the painter's role was a co-operative one. His co-operation often began with the master mason. There are rare instances where the painter and mason may have been the same: Giotto, author of the frescos in the Arena Chapel at Padua, may also have been the Chapel's architect, and was later in charge of the construction of Florence Cathedral's great campanile. For the most part the two professions developed separately, while interacting closely. As styles of building changed between the twelfth and fifteenth centuries, the work of the painter was slowly reoriented. There is little truth in the idea that the new skeletal Gothic architecture reduced opportunities for painters to work on walls and encouraged them to work on smaller panels instead. Most late medieval buildings still presented ample wall space, and panel painting flourished in Italy alongside colossal wall-painting projects. The changes were instead conceptual; Romanesque buildings

35 The east wall and vault of the painted wooden church from Aal, Norway, late thirteenth century. The Gospel illustrations, including the Last Supper, are executed with the clarity and vigour typical of contemporary parish church art in northern Europe.

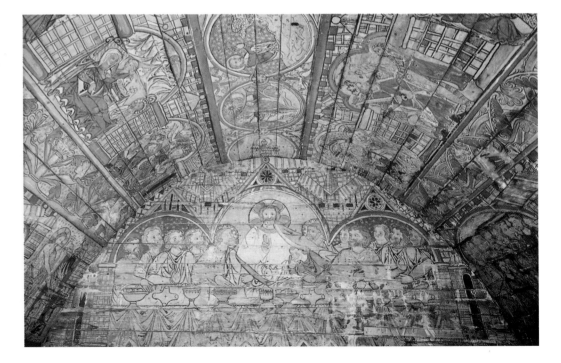

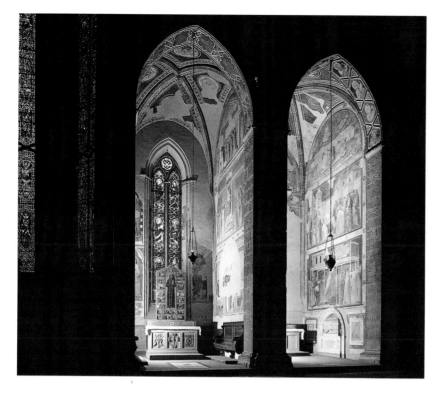

were usually decorated more formally and monumentally than Gothic ones, and Gothic buildings required a different type of decorative work, more responsive to the characteristics of the Gothic idiom as a whole, as well as to the more diverse demands of late medieval patronage.

Contemporary responses to the new architectural style are so few that today we cannot know how it was actually perceived, and what was thought important or new about it. What appears to modern viewers as the salient point about great French Gothic churches, their stupendous play with thin elegant structural elements, went largely unremarked in the Middle Ages. That buildings like Notre Dame in Paris or Chartres Cathedral were conceived as self-conscious expositions of a new form of structure is witnessed by the original polychromy of Chartres Cathedral itself. This consisted not of figures or delicate ornament but rather of painted masonry done in ochre and white. The bleak, regular patterning concealed the less-than-perfect stonecutting of the real building underneath, and even contradicted it, since the giant clusters of wall shafts which shoot up to the vault were originally picked out in white as continuous vertical tube-shaped members separated from the wall like drainpipes, whereas their stonework is partly coursed horizontally into it. The painter is here idealising the masonry and picking out its significant parts, the wall and vault ribs, in a way inconceivable without the master mason's guidance. Here the painter's art is expository: it crystallises the design and demonstrates to us in what ways it was aesthetically significant.

As a style of building, Gothic was itself heterogeneous and did not dictate a single solution to its decoration. Thirteenth-century England, for example, evolved a mature national version of Gothic whose structural principles were generally unlike those of the French great churches, and whose decorative policies were appreciably less austere. At Salisbury Cathedral, for example, the comparatively severe and decorous interior begun in 1220 preserves repainted examples of ornate mid thirteenth-century murals on the vaults of its choir and 38

36 *Above* The east end of Santa Croce in Florence is one of the most richly painted interiors of the Middle Ages.

37 *Right* Structure enhanced: reconstruction of the original polychromy of the interior of Chartres Cathedral.

sanctuary. These comprise huge roundels depicting biblical figures, a Christ seated in Majesty with the symbols of the Evangelists, and calendar scenes adorned with foliage. The paintings, in their placement and grandeur, emphasise the most important part of the church, the area of the choir and high altar. But they are quite unlike the virtuoso French conception of a vault as a surreal expanse of masonry miraculously held aloft. Despite their metaphorical value as celestial surfaces (vaults were often painted blue with golden stars), the Salisbury vaults are deliberately made to conform with the solid pictorial idiom of objects in the thirteenth-century terrestrial world, such as coloured enamels or book illuminations. Much the same holds true of a slightly smaller fourteenth-century interior like that of the Lady 39 Chapel at Ely Cathedral (completed in the 1340s) whose ebullient but congested style of wall articulation and sculpture was enriched by heraldic colours, traces of which can be seen today.

The richly impressive effect of interiors like that at Ely is a measure of the transformative powers of the painter-decorator. Whereas at Salisbury the vault decoration probably reflects clerical tastes, in the case of the Ely Lady Chapel the painter was decorating a space deliberately set aside for the townsfolk, especially women, to express their devotion to the Virgin Mary. The painstakingly delicate character of its coloured decorations reminds us of the contemporary taste for painted wooden altarpieces and screens, like the plentifully-produced carved altarpieces made in fifteenth-century Flanders, and their near relatives in England, the cheerful rood screens in parish churches, inscribed with the Apostles' Creed and portraying the Church Fathers, the Apostles, the heavenly hierarchy and so on.

38 *Top* The vaults of Salisbury Cathedral, although much repainted, retain the main elements of mid thirteenth-century painted roundels.

39 *Left* A detail of a bay from the fourteenth-century Lady Chapel at Ely, showing traces of the original colours.

40 The fifteenth-century rood screen at Southwold, Suffolk, here showing the Apostles, exhibits the richly-worked surfaces of Late Gothic panel painting.

40 The rood screens at Southwold and Ranworth rank as triumphant survivals of day-to-day painting in late medieval England. They are the parishioner's art, since customarily the parish was responsible for the nave and its screen, the rector for the chancel and high altar area (technically this is still true). The medieval chancel screen kept the layfolk away from the sanctuary and high altar where Christ appeared at Mass, and so de-emphasised the congregation's importance in the liturgy of the Church. Instead it provided them with a protective visual litany of angels and saints. It was also an expression of the parish's corporate self-image, a potential arena for competition between parishes and, symptomatically, often bearing the heraldry of a local bigwig. Screens, where they survive, create smaller more private spaces within the airy volume of medieval churches, reminding us of the domestication of the late medieval religious mentality of the middle classes. The lighthearted textile representation and textile-like brocaded gilt gesso work behind the painted figures on such screens belong to a world of commerce and material well-being.

Rood screens also exemplify the role of the

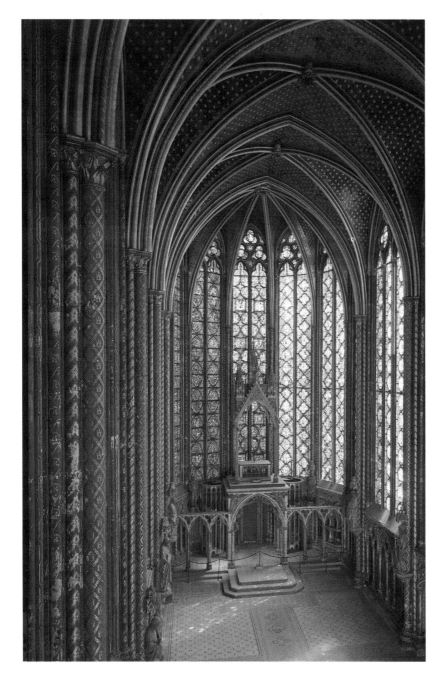

41 The upper chapel of the Sainte-Chapelle in Paris, built and decorated in the 1240s.

painter as someone who not only painted but also moulded the surfaces upon which he worked. If the patron could afford it, his painter could model and scrape the gesso ground upon which the images were painted so as to give it relief which, when gilded or coated with tinfoil, sparkled. Such effects seem to have been characteristic of Romanesque and Gothic painting. The term 'illumination', applied to manuscript painting in the Middle Ages by Dante in his *Divine Comedy*, is anticipated by the commentary on monumental painting in the twelfth-century treatise of Theophilus, who writes of the addition of '*luminae*' (highlights) to painted 52 figures. To the informed medieval audience, a brightly reflective or glittering surface could convey several ideas simultaneously, since medieval science, theology and taste were closely related in such a way that the perceived world was thought of as an emanation of the supernatural.

One of the most glittering and influential painted interiors of the Middle Ages which embodied these diverse yet ultimately related principles — an interior easily surpassing in authority any of the great Italian frescoed interiors — was that of the French King Louis IX's chapel in his palace by the Seine in Paris: the Sainte-Chapelle, built and largely decorated between 1243–8. The Sainte-Chapelle is one of 41 the best examples of the major role taken by polychromy in heightening and shaping medieval religious experience. Its lavish interiors, now heavily restored but known through good nineteenth-century copies, exemplify the way that royal painters could create a theatrical showcase for a great relic: in this case the Crown of Thorns worn by Christ at his Passion, kept on a special platform in the upper chapel of the Sainte-Chapelle.

The Sainte-Chapelle was described by a contemporary Pope as exemplifying Ovid's dictum *opus superabat materiam*, used here in its medieval sense as a form of praise for great workmanship, irrespective of the materials actually employed. With the exception of the precious reliquaries displayed in the chapel, little in the Sainte-Chapelle was truly precious, although its workmanship made it appear so,

and that was what mattered. The painters co-operated with the stained-glass makers to concoct a giant translucent simulacrum of a contemporary metalwork shrine turned 'outside in', using no more than glass, plaster, putty and tempera paint, with gold leaf. The vaults of this lantern-like building were originally a deep royal blue, spangled with gilt stars. The thin wall ribs, and the richly carved arcading on the solid areas of wall under the windows, were diapered with colour and gilded. Small medallions in the arcade just above eye level were set with glass placed upon a silver ground to reflect light. They framed small paintings of the martyrdoms of saints, a theme echoing that of the Passion of Christ recalled by the main relic. Tiny rectangles painted in imitation of enamel patterns were also set into the walls. As in medieval alchemy, the base was converted into the precious.

The Sainte-Chapelle is a specialised example of an approach to interior decoration that could be found elsewhere in western Europe. It represented a certain ideal of aristocratic patronage: Henry III of England, when he saw it in 1254, was said to have admired it so greatly that he wished to carry it off in a cart. It also displayed the art of the painter as one not solely of representation (the figurative pictures in the Sainte-Chapelle are small, drawn out on the scale of the figures in the stained glass) but also of mimicry, of the cosmetic. The cosmetic aspect of the painter's work was of course socially much more widespread, and it carried with it the risk of disapproval. In a moralising late fourteenth-century sermon on the most celebrated of all whores, Mary Magdalene, Master Rypon of Durham said:

... certain women give artificial decoration to themselves by painting their faces to please the eyes of men. In truth, whosoever do so have the true likeness of harlots ... and ... are well well compared to a painted sepulchre in which lies a foul corpse.

By the fourteenth century, it was normal for women to apply cosmetics. The practice was attacked mercilessly, and by people who were wont also to criticise the over-elaborate colouring of churches with their 'peyntid roofis above' for pride and vanity. Undercutting the old literary ideal of the excelling artist was a no less

42 The tomb of Bishop Bronescombe (d.1280), Exeter Cathedral. The painted effigy preserves its original coloration. The canopy, with modern paintwork, is fifteenth century.

venerable, but on the whole less widespread, suspicion of any craftsman who employed manual dexterity dishonestly to enhance or copy appearances, and especially to 'trump them up' with colour. For this reason painters were occasionally included amongst illicit traders.

Master Rypon's image of the painted sepulchre is also up to date. Colour was becoming an important means of decorating the elaborate tombs characteristic of church interiors from the thirteenth century onwards. Earlier in the Middle Ages, burial in church was socially restricted, whereas by Master Rypon's time gaily-adorned tombs were increasingly common. The methods used on the most elaborately-painted aristocratic and episcopal tombs at Westminster Abbey, Rochester and Exeter, are strikingly reminiscent of those employed in the Sainte-Chapelle. Glass is used to imitate the jewellery of vestments, and varnished colour employed to add corporeality and luminosity to the faces and hands of the effigies. The effect is also like that of a very cheerful waxwork. Indeed by the fifteenth century, with the burgeoning at court of the art of portraiture, painting and

42

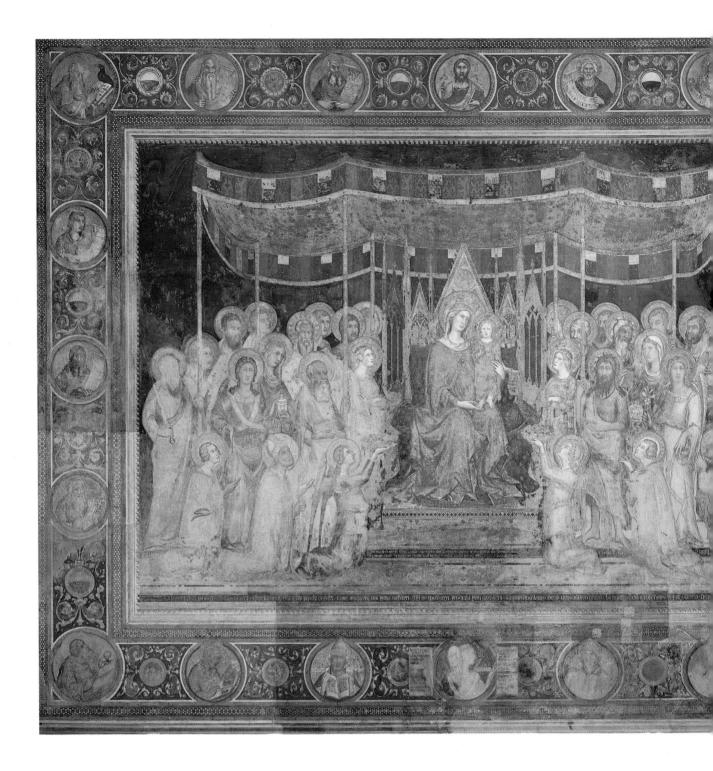

44

waxworking had coalesced in an art form which reflected the contemporary elaboration of death ritual: the ceremonial wax funeral effigy. We know that French royal court painters such as François d'Orléans and Jean Fouquet could be expected to make and colour wax funeral effigies of French kings. The range of expertise attributed to painters by Cennino Cennini, who writes at length about taking casts of whole human bodies, held true. The celebrated portrait painter François Clouet was even summoned to examine the body of François I on the very day of his death in 1547. He had come to take a cast of the King's face while it was still reasonably fresh, to form part of an effigy clothed in gorgeous royal ceremonial garb. Bizarrely, this effigy was not only displayed at the king's funeral but was also waited upon hand and foot and ritually fed as if it were the king himself. The effigy represented the office of kingship and was treated accordingly.

The example of French wax funeral effigies reminds us yet again of the importance of coloured images in the medieval outlook. When the Sienese painter Simone Martini came to decorate one of the council chambers of the Town Hall at Siena in the second decade of the fourteenth century, he created a magnificent *Maestà*, a Virgin and Child enthroned majestically beneath a state canopy and surrounded ritualistically by an entourage, a court, of saints. He was reproducing a type of image which survives today in the famous *auda* of Seville, an image of the Virgin Mary dripping with gemstones which is paraded festively through the town beneath a canopy supported on posts. In its general character as a picture, Simone's mural followed Duccio's *Maestà*. This was a giant altarpiece which, when completed in 1311, was carried through the streets of Siena from the workshop to the Cathedral rather like an *auda*,

43 The *Maestà* painted by Simone Martini, *c.*1315, exhibits a range of decorative techniques. The execution proved faulty and the mural was repainted within a few years by Simone.

to the accompanying clamour of trumpets and castanets. What glorified the high altar of Siena Cathedral glorified also its government buildings. Simone's artistic approach was as brilliantly eclectic as that of the Sainte-Chapelle painters: he mixed his techniques (secco and fresco techniques both occur in the mural), ornamented the gilded surfaces of his mural with small relief patterns and attached glass gemstones to its surface, so dressing it up.

The process of technical and imaginative cross-fertilisation between the media apparent in fashionable Italian art of the early fourteenth century is gorgeously exemplified elsewhere in Europe by some of the strangest and most self-consciously 'medieval' interiors ever decorated: those in the fourteenth-century Castle of the Holy Roman Emperor Charles IV at Karlstein, near Prague, then in Bohemia. Charles IV was one of the grand eccentrics of the Middle Ages, and had in his service a painter called Master Theodoric. In the 1360s, Theodoric decorated the interiors of Karlstein with a blend of softly-modelled paintwork, gilt relief gesso and rough-cut yet polished purple stonework. The effect was an unprecedented revival of the standards of display of much earlier Romanesque and Byzantine art. Medieval styles did not progress straightforwardly but were often capable of radical bouts of conservatism, if the needs of the patron so required. To judge from his art, Master Theodoric must have studied in northern Europe, in the Rhineland and in Flanders, and also in Tuscany, and so in some of the most 'progressive' centres of the period. But only a patron could have determined the bizarrely eclectic outcome apparent at Karlstein. In the Chapel of St Catherine in Karlstein Castle, Charles ordered irregularly-cut stone shields to be jammed into the gilded mortar, emblems of feudalism made part of the 'fabric' of the Empire. But Karlstein was new, and its apparent antiquity was a product of its novelty. Its painters and stonecutters invented a tradition reflecting the imagery of medieval romance and the description of the Heavenly Jerusalem set with precious stones in the Revelation of St John.

Oddest and most effective of all at Karlstein is the gallery of saints, many of them Bohemian,

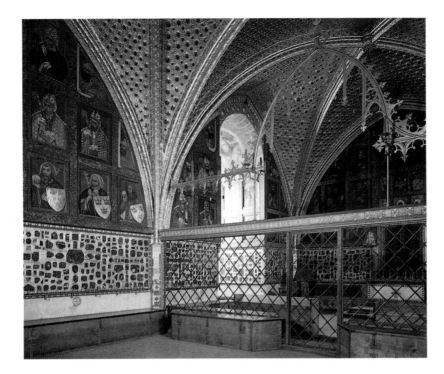

icon-like saints, painted on wood panels set against the wall in tiers like a portrait gallery. These stolid tuber-nosed folk stand in a curious relationship to the painted field since some overlap their frames while others disappear behind them. However, the shields held by the 45 saints in the lowest tier 'perform' in space, since they are simply wooden shields decorated in relief and stuck on to the picture surface in such a way as to imply that the figures are looming forwards towards us, half paint, half sculpture. This play with surface and space demonstrates how medieval painters, like sculptors, thought in three dimensions; they could either represent the appearance of something in paint or, alternatively, make what they were attempting to represent. For this reason painters and sculptors sometimes both attracted the name 'Imagier', maker of images.

The fact that the bygone holy men of Bohemia should be given heraldic shields at all also reflects the love of emblematic ritual typical of this period: heraldry was its greatest and most profuse expression. Here, in an art inherently devoted to colour, the medieval painter came into his own. From the thirteenth century onwards, the role of painters as manufacturers of the coloured paraphernalia of feudal society — shields, banners, tents, jousting harnesses, beds, hearses, horse-armour, boats, carriages and so on — was guaranteed by virtue of the speed and flexibility of the painter's techniques of execution in comparison with those, say, of the embroiderer. Stencilling made possible the rapid decoration of literally acres of cloth, as well as wood or plaster. Great painters, like lesser ones, worked on such projects: Walter of Durham, Simone Martini, Hugh Peyntour, Gilbert Prince and Melchior Broederlam are all known to have executed such work.

Surviving examples of this type of output are rare, probably because the originals were mostly considered to be disposable and rough in technique. Of superior and more permanent character, however, are the magnificently chivalric late fourteenth-century funeral 'achievements' of Edward, Prince of Wales, the Black 46 Prince (d.1376). These consist of his gauntlets, crested helm, shield and *jupon* (tunic), apparently

44, 45 The Holy Cross Chapel, Karlstein Castle, Prague, decorated *c.*1360 by Master Theodoric for the Emperor Charles IV: general view (above) and gallery of saints with wooden shields (right).

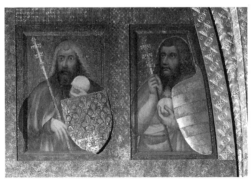

44 which adorn the Chapel of the Holy Cross, a chapel which, in its devotion to Christ's Passion and the saints, thematically resembles the Sainte-Chapelle. The low vaulted interior of this chapel is studded from top to bottom with sparkling surfaces, star-shaped mirrors on the vault and irregular cut stones on the gilt dado. The sharp focus of this encrusted aesthetic, which must have been prodigiously effective by candlelight, is set off against Master Theodoric's

46 Coloured but faded remnants of worldly fame: the helm, tunic, shield and gauntlets of Edward the Black Prince, *c.*1376, at Canterbury Cathedral. The helm's damaged crest and the shield quartering the arms of England and France use painters' techniques.

47 The Coronation Chair, Westminster Abbey. Executed by the royal painter Walter of Durham in the late 1290s, the design follows a bronze prototype designed in turn by a goldsmith. The chair was repainted at least once in the Middle Ages.

made in the Prince's armoury and suspended after his funeral over his tomb in Canterbury Cathedral. The tomb's epitaph even refers to the way the Prince had been deprived by death of his noble trappings and status. The leopard crest and shield blazoned with the royal arms were originally brilliantly coloured and gilded. They still bulge and ripple with gesso laid over moulded stuffed leather in exactly the same eye-catching and threatening fashion as the shields at Karlstein. We are reminded by such colourful padded harnesses of the affiliation of painters and saddle-makers, and indeed the techniques of moulding and casting crests with white leather and gesso are mentioned by Cennino Cennini.

The craft of medieval painting was thus not solely pictorial; it embraced not only flat surfaces but any object that needed colouring and shaping. The techniques we have been considering were by-products of an increasingly sophisticated, yet inherently practical, medieval culture and market. If a coloured wooden object was required, the painter may well have had a role in its overall design. This is likely to have been especially true of painted furniture, since in the Middle Ages gaily coloured beds and seats were popular. There are numerous recorded instances between the twelfth and fifteenth centuries of painters making painted chairs, for example. One exceptionally rare survival, the so-called Coronation Chair, is at Westminster 47 Abbey. This was made and painted in the late 1290s by the English king's master painter, Walter of Durham, although the design was established by the king's goldsmith, Adam. The chair was important since it was put beside the shrine of the national saint, Edward the Confessor, and was designed in such a way as to hold and display the Stone of Scone, a relic of Edward I's subjection of Scotland, beneath the seat: the chair was deliberately planned to be a reliquary or trophy-case. Later it was one of the seats used in the royal coronation service, and is so used today. Most medieval painted objects have ceased to be objects of use or veneration. The Coronation Chair, linking as it does art and ritual, is one of the very few extant medieval painted objects which still retains something like its original role.

3 THE PROCESS

COMMISSIONS AND CONTRACTS

In its essentials, the activity of medieval painting was exactly the same as that found today, with certain obvious exceptions, most notably the fact that painters prepared their pigments themselves. Proprietary pigments were only widespread by the nineteenth century. Of the appearance of painter's workshops and of their working environment, we know little beyond the few illustrations considered in the first chapter. We have nothing to compare with the surviving tracing-houses and lodges of medieval masons. The craft of painting, especially wall painting, was in its practical arrangements altogether more transient than building. Wall painters had to fit in with the routines of church and residence. Nevertheless, their work still required more permanent controls – not the general aesthetic and doctrinal controls considered in the second chapter, but rather the more prosaic and specific controls of the specification for each painting, the mandate or contract. That is the appropriate starting-point from which to consider the processes involved.

With the exception of smaller, speculatively-produced painted images, medieval paintings were bespoke, commissioned by a specific person or persons for a specific purpose. Painters were usually contractors, and as such had to arrive at a prior agreement with their patron. Few such contracts survive before the late thirteenth century. Since painters served professionally to articulate the visual imagination of the patron, their relations with patrons at the binding stage of an agreement could be close. In many cases the control of the patron was paramount: in medieval terminology, *patron* was another word for design, indicating the close link between client and formula. In other cases, a patron might be able to suggest a general theme, or indicate that it should be 'like' a painting he had seen elsewhere (this was quite common); but it was up to the expertise of the painter to flesh this suggestion out.

An early example of an agreement relating to the execution of a wall painting is provided by an English royal record of 1256 in which the king's painter, William of Westminster, negotiated the subject-matter of a mural directly with the mildly paranoid King Henry III. The basis of the agreement was a spoken exchange, the phraseology of which is echoed in the original document, here translated from the Latin:

The King lately at Winchester in the presence of master William the painter, monk of Westminster, ordained and required the making of a certain picture at Westminster, in the garderobe [lavatory] where the king is accustomed to washing his head, of the king who was rescued by his dogs from the sedition plotted against him by his subjects; concerning which painting the king has sent to you, Edward of Westminster [Keeper of the King's Works] other letters. Also Philip Luvel, his treasurer, with the aforsaid Edward of Westminster, is ordered that master William should have all the necessaries for making the aforesaid painting without delay.

It is unclear from this document whether painter or king chose the subject. The image derives from the popular contemporary illuminated Bestiary manuscripts telling moral stories about animals, in this case about the loyalty of dogs. [48] There is no way of telling whether the king described a predicament he wished to be illustrated, to which the painter was expected to find some sort of pictorial analogy, or whether he simply set an illuminated Bestiary before the painter and demanded a blow-up copy. The former is not impossible. The twelfth-century cleric Giraldus Cambrensis describes a mural in the royal castle at Winchester depicting a royal eagle pecked by four eaglets, the imagery of which had been described by King Henry II to an artist who then executed it. The symbolism, again wrought in terms of the Bestiary, concerned Henry II's anxieties about the disloyalty of his sons; its purpose was thus to illustrate an essentially private concern. Henry III's later mural about dogs also served exactly the same symbolic purpose, a daily reminder of the trials and tribulations of kingship, present before him

48 *Above* The story of the King of the Garamantes rescued by his dogs from his treacherous subjects, from a mid thirteenth-century English Bestiary manuscript.

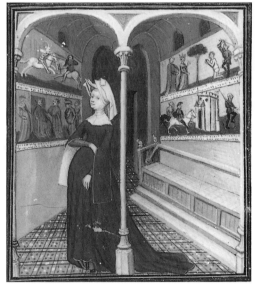

49 A rare illustration of medieval mural paintings and their viewer, from Christine de Pisan's *Mutacion de Fortune*.

every day in his washroom. Painters needed to respond with diplomacy and resourcefulness to such promptings. An unambiguous verbal formula was then necessary to record a binding agreement enforcable by the Keepers of the King's Works, often cultivated men: Geoffrey Chaucer was for a short period Keeper of the Royal Works at Westminster.

In his much earlier *History of the Franks*, Gregory of Tours (*c*.538–594) describes how a church at Clermont in France was decorated in the fifth century at the behest of a wealthy patroness who:

wishing to adorn it with colours … used to hold a book open in front of her, reading the histories of deeds of long ago and indicating to the painters what they should represent on the walls.

Whether this type of direct involvement by patrons in church decoration was normal is extremely hard to say. It must have been usual in domestic painting, where a sense of intimacy between patron and image was inevitable. This idea is exemplified by an early fifteenth-century illustration of a medieval viewer, the authoress Christine de Pisan, relaxedly appreciating murals in the fictional Castle of Fortune. A discriminating and well-documented female patron of this type was Mahaut, Countess of Artois and kinswoman of the French royal family. In 1320 Mahaut entered into an agreement with her painter, Pierre de Bruxelles, concerning the decoration of her residence at Conflans, near Paris, with murals depicting her father's crusading exploits. The agreement, translated here from the vernacular French, records that:

First, the ground [*champ*] of the pictures is to be of the finest wainscot available; on it will be [shown] the image of the count of Artois everywhere depicted with the arms of the said count, and other images of knights bearing several colours with their arms wherever they appear: and it will be discovered what arms they bore when they were alive. And there will also be the galleys, boats and vessels of the sea equipped with armed men, the said vessels shown as if they were in the sea in the very best way that they can be painted. And the said Pierre will depict a border around these images, and above them will be inscriptions which explain succinctly the story of how the count threw two barrels of wine into the fountain. Thus

will one of the gables of the gallery be painted. And the said knights will bear helmets, armour and swords such as pertain to armed men, depicted with tin, also with silver and gold. The other gable will be done as the said lady would like.

The agreement goes on:

An he [Pierre] will base the images and histories in the said gallery on the model provided by a roll [rool]. And everything will be painted in oil and the finest available colours as Pierre promised in our presence.

There is much here that is eminently practical. Like Henry III, Mahaut has clearly dealt with her painter in person. She is specific as to certain priorities: good materials are to be used, and the appropriate heraldry is to be added after the necessary research on it has been be done by the painter; inscriptions are to explain clearly one specific episode, an obscure family joke; and Pierre is to follow an agreed-upon drawing done on a parchment roll. He is also to adhere, at his own risk, to a prior agreement about his remuneration, exceeding it only at his own expense. The techniques mentioned – oil paint on wainscoting, with gilded and silvered tinfoil appliqué work for glitter – were all well established by the 1300s. There was to be nothing experimental about Mahaut's murals: accuracy, comprehensibility, durability and economy were essential.

Agreements vary in content with the form of patronage. Mahaut's is fairly trusting. In Italian city states whose governing communes patron-ised art, relationships between painters and clients were more purely commercial than those usually found at court. Thus more formal, less personal, agreements, true contracts, were needed as precautions. In 1285 the Clerks of Works of one of the fraternities attached to Sta Maria Novella in Florence commissioned a panel painting from Duccio, the Sienese artist, which is probably identifiable with the Rucellai Madonna. The surviving contract specifies that Duccio has promised and agreed to paint the panel with the image of the Virgin Mary according to the (unspecified) wishes of the clients, and that he would have to accept responsibility for the final product if it proved unsatisfactory. The same written vagueness

about subject-matter, presupposing a more pre-cise but lost oral specification, is true also of the contract for the high altarpiece of the Cathedral of Siena commissioned from Duccio in 1308, the *Maestà*, which also mostly survives.

Duccio agreed with the Clerk of the Works:

to make the said panel as ever he was able . . . and to work continuously upon it at such times as he was able to work on it, and not to accept or receive any other work to be carried out until the said panel shall have been made and

50 A richly documented medieval painting: the west face of Duccio's *Maestà* of Siena Cathedral, executed 1308–11.

completed ... [Duccio is to be paid] sixteen *soldi* of Sienese money for each day that the said Duccio shall work with his own hands on the said panel except that if he should lose any part of the day there should be a deduction from the said salary established in proportion to the time lost ...

In like manner, the said Clerk of the Works ... promises to supply and to give all those things which shall be necessary for the working of the said panel, so that the said Duccio shall be bound to put nothing into it except his person and his work ... Moreover the said Duccio, for greater precaution, swore voluntarily on the Holy

Gospels of God, physically touching the book, that he would observe and implement each and everything in good faith and without fraud.

In essence this rather demanding agreement is a form of retainer. It holds Duccio solely to this work, on oath 'for greater precaution', and materials are to be handed to him to strengthen his obligation to the patrons. This type of retainer is problematic, since one of its central requirements — that Duccio should be the only one to work on the panel — is only comprehen-

sible if we recall the hierarchical structure of painting workshops described in the first chapter. What is meant by the retainer is that Duccio is to be sole master of the project. Collaboration of masters is thus ruled out. Duccio's chosen assistants' hands are regarded as an extension of his own. For a panel painting of the *Maestà*'s size, 4.7 m wide and 5 m high, including dozens of narrative pictures and elaborate woodwork as well as the main subject of the Virgin Mary, several types of expertise were necessary, and the co-operation of assistants would be essential.

Fifteenth-century contracts for paintings are even more matter-of-fact and explicit. In 1402, a prebendary of S. Maria de Copons in Spain entered into a contract with the Valencian painter Lluis Borrassa for a great altarpiece. The surviving document is remarkably detailed, specifying the dimensions and shape of the work, its manufacture from seasoned poplarwood, and the extent of Lluis' responsibility for all the stages of manufacture. The subject-matter is specified precisely, as is the delivery date, June 1402, only six months after the contract which is dated January of that year. Payment is in stages, by inspection: one sum at the time of contracting, another after construction, execution of preparatory ground, drawing and gilding; and a final sum on completion. The issue of quality is paramount:

Item, it is agreed that all this work is to be made of fine gold of Florentine florins ... it is thus understood that the mantles of the Madonna Saint Mary be all of good and fine Acre blue, and some other images also to be of the said blue. And the top layer will be painted of good and fine colours, including beautiful carmine ... according to what is customary in other beautiful retables.

MATERIALS AND METHODS

So much for the patron; but what modes of thinking did medieval painters bring to bear upon the realisation of their commissions? To a large extent, their concerns were those of the clientele. In 1480 some angry painters in Seville protested to city authorities that the city needed to regulate maladroit painters:

In this city there are some who call themselves painters who not only are not, but also don't even know how to

51 'Color' envisaged in terms of the painter's dish; an initial from *Omne Bonum*, the earliest alphabetical encyclopaedia, English *c*.1350.

classify colors as they ought to, nor to process them for painting, and because of this what they paint is badly and thoughtlessly painted and the colors are lost and fall off ... there is danger to the public good that the said painters are found making and make works with false and bad paints and badly made.

Bad painters were able to discredit the good; they and their products were judged by the standards of other paintings, or 'what was customary' by way of quality. Hence the guilds' insistence, whether in Siena or Seville, on the use of pure materials: German azurite was not to be passed off as ultramarine, nor gilded silver as pure gold. Honest materials meant honest practice. The theme of custom as the guarantor of quality, and so of the common civic good which all trades were to observe, is central to an understanding of how medieval painters worked. As we saw in the first chapter, writers such as Theophilus and Cennino thought habitually in

terms of inherited skill, and thus traditional knowledge in the handling of materials, rather than progressive achievement, uninherited genius or systematic aesthetic ideals. To handle a material well was to understand it and, to a medieval mental 'set' attuned to the integration of all stages of art production, required its understanding.

It is partly for this reason that the extant medieval treatises on painting are predominantly technical manuals which deal in fullest detail with the preparation of gesso, colours, media (water, tempera or oil) and varnishes. Painters had first to understand the properties and classification of colours themselves. Opening the first book of Theophilus' treatise we find thirty-eight short chapters on painting devoted primarily to the preparation of materials: colours, varnish, gold leaf and so on, in keeping with their character and origin. The actual aesthetic system within which such methods worked is described less clearly. Chapters one to thirteen leap straight in with 'the mixing of colours for nude bodies'; they are followed by chapters which deal with monumental painting, staining, varnishing, gilding, translucent painting and finally miscellaneous comments on illuminating and ink-preparation. Only in the middle of chapter fifteen, 'mixing colours for draperies in wall painting', do we reach the logical starting-point for wall painting:

When figures or representations of other things are portrayed on a dry wall, first of all sprinkle it with water and continue until it is completely wet. All colours which are to be used on it are mixed with lime and applied to this wet surface so that, as they dry with the wall, they adhere to it.

Theophilus is describing a process related to *fresco* painting on wet plaster (one fundamental to much German Romanesque painting), but in such incidental terms that the impression is that of a cookbook written without the discipline of a menu.

Nearly three centuries later, Cennino's *Il libro dell'arte* presents us with a far more explicit account of painting, yet one which still adheres to the medieval stress on understanding materials. Having tackled drawing as the prerequisite of painting, Cennino immediately links to it the practical matters of quill-cutting, paper-tinting and starting a portfolio. His next section then turns quickly to the character and application of colours. Cennino's system of seven natural colours, four mineral (black, red, yellow and green), three natural (white, blue and yellow) is symbolic. It echoes medieval metaphysics: pigments were materials, and materials – as for example certain stones like sapphires, lapis lazuli or emeralds – were held in the Middle Ages to possess active and symbolic qualities. Blue sapphire was the 'gem of gems', possessing sacred virtues, able to protect its bearer from harm, to reconcile him with God and to dispose him to prayer. Such qualities easily transferred themselves back to the colours made from such materials. It is no wonder that patrons worried about the quality of the ultramarine pigment, lapis lazuli, used for the garments of one of the greatest of all mediators between man and God, the Virgin Mary herself. We have already discussed the active intervention of painted images in medieval life; their colours were part of that action.

Pliny the Elder tells that it benefited the eyes to place green emeralds over them, and green, also a cheaper pigment to use in large quantities than blue, was often applied to domestic interiors as a youthful, health-giving and fertility-inducing influence. Green wax was often used for seals to signify the fresh longevity of the contents of the document to which they were attached. Indeed, many of the medieval painter's pigments came from apothecaries dealing in minerals for medicinal purposes. In Florence, painters belonged (with saddlers and barbers) to the *Arte dei Medici e Speziali* – the guild of doctors and apothecaries.

The rich associations of colours encouraged medieval writers to construct colour codes. An example is that of St Antoninus, in which white signified purity, red charity, yellow/gold dignity, and black humility. Such codes were often contradictory, and cannot be taken out of context. Yellow could also signify envy or treachery: for example, Judas wears a brilliant yellow cloak in Giotto's mural of the betrayal of Christ in the Arena Chapel. Painters had to understand the significance of colours in terms

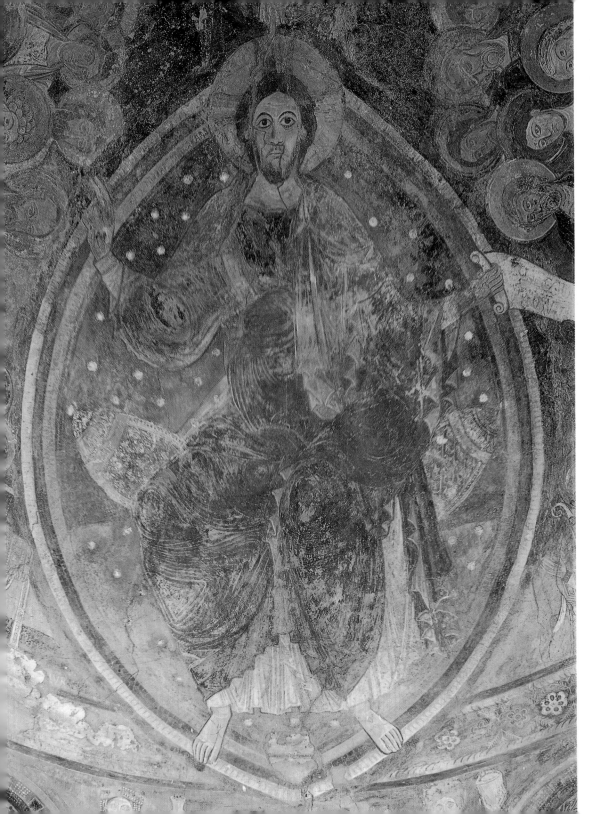

52 Christ in Majesty, in the apse at Berzé-la-Ville, France, early twelfth century. A magnificent Romanesque mural of Theophilus' period, whose ground is set with small reflectors in order to sparkle; 'luminae' or striated highlights are used on the radiant garments of Christ.

53 A mid fourteenth-century Italian apothecaries' shop.

Sagremor's yellow and green shield, a personal leitmotiv indicating that his colours infringed the laws of heraldry just as his behaviour infringed the chivalric code of conduct.

Apart from the rule-governed practicalities of painting, which had to be learned by experience within the painter's shop and which can alert us to the wider significance of colour and technique in paintings, other forms of knowledge were presupposed, predominantly knowledge about images themselves. Remarkably little is known about how painters learned to compose images of varying complexity, how they acquired and retained knowledge of pictorial conventions, and how they learned at what point innovation was desirable or possible. The evidence does not always add up. For example, the Parisian painters' statutes of 1391 directed that when wall painters repainted murals they should eradicate all the surviving colours of the old picture. On the other hand, there are blatant examples of new paintings being executed over old ones and adhering closely to the old subject-matter, as for example in the twelfth- and thirteenth-century murals of the Deposition of Christ from the Cross in the Holy Sepulchre Chapel at Winchester Cathedral. Tradition was undoubtedly a major force in religious painting. Painting conveyed the truths of a supposedly unchanging belief system. The preservation by copying or reproduction of what was believed to be the authentic likeness of a holy person helped to ensure the spiritual effect of an image. When medieval commentators praised a written text, its correctness and authenticity, not its beauty of script, were uppermost in their minds. In Byzantine culture, the preservation of an authentic painted likeness was rendered important by the belief that icons reflected an essence related to that of the holy person depicted. Authenticity was truth, hence the almost priestly authority of the image of St Luke painting the Virgin, and the spiritual benefits of praying to the Veronica, the image of Christ's face.

Byzantine evidence for image-composition is far more plentiful than that for western Europe, perhaps because Byzantine culture was more consciously conservative and convention-

of the *overall* meaning of the particular work on which they were engaged, which required a general knowledge of images, their inter-relationships and accepted colour-decorum. The most formal colour system developed in the Middle Ages, familiar to all painters, was found in heraldry where colour combinations were predominantly practical. They were determined by the ability to distinguish certain colours at a distance, and by the chemical incompatibility of some pigments. Thus one could set metals and colours side by side or upon one another, but not colours with other colours. Medieval romance writers were sufficiently well aware of this system to be able to attribute coats of arms with 'bad' tincture-combinations to morally inferior literary figures, such as the Arthurian

bound. There survives, for example, the eighteenth-century *Hermeneia* or guidebook of Dionysius of Fourna, whose text, essentially medieval in outlook, begins with the materials and methods of painting, before recording at length the various formulas for narrative Bible paintings, working methodically through the Old and New Testaments. Clear instructions are also given for the decoration of certain types of religious building. Explicit literary traditions of the *Hermeneia* type are not preserved in the case of western European panel and wall painting. Most of what we know has to be inferred either from contractual or other documentary evidence, or from the more plentiful resource of manuscript illumination, where the processes involved in formulating images are more fully understood.

In the case of wall painting, documents occasionally hint at the use of prior models in one form or another. Mahaut d'Artois' agreement with Pierre de Bruxelles alludes to a *rool* or cartoon, presumably drawn up by the painter. Illuminated manuscripts sometimes furnished painters with schemes perhaps otherwise unknown to them: in the 1350s the Dauphin of France sent a book of the *Faits des Romains* to his painter Jehan Coste, as the model for a life of Julius Caesar to be painted at the castle of Vaudreuil. A few sketches for Italian altarpieces survive. But generally, individual designs or compilations of designs are rare. Common sense suggests that the larger wall-painting commissions of fourteenth-century Italy required fairly detailed planning at the stages of contracting and 'ordination', or setting-out, of a scheme by the master painter. But whether this entailed the creation of large designs, akin to the architectural drawings emerging in the same period from the masons' lodges, is unknown. Large-scale designs are likely to have been especially useful in guiding decisions taken in committee, matching the explicitness of written contracts in their clarity, decisiveness and ability to inform clearly about the financial implications of a scheme. They must also have been obligatory when a painter provided designs to be executed in another medium, as in Jean Bondol's provision of cartoons for the Angers Tapestries.

The smaller surviving 'model books', such as the exquisite English sketchbook of about 1400 in the Pepysian Library at Magdalene College, 54 Cambridge, are far from explicit about their original function: they could pertain to virtually any medium, including embroidery. The sketchbook preserves isolated and pictorially incoherent *exempla* distinguished only as exercises of imaginative pictorial artifice, boosting the artist's repertory much as a medieval preacher might equip himself with showily effective anecdotes. It does not seem to preserve formal pictorial traditions for religious subject-matter. In fact, it appears to represent quite the opposite phenomenon, the celebration of innovative and individual design.

Drawings of the type in the Pepysian sketchbook seem to preserve formulas of the type an artist or workshop might guard jealously. Indeed, it was in the period around 1400 that the issue of copyright began to surface in disputes such as that in 1398 between one of Jean, Duc de Berry's painters, Jacquemart de Hesdin, and another painter, John of Holland. John complained that Jacquemart had broken open John's strongbox and stolen some of his colours and models (*patrons*). The fact that they were in a stongbox at all is symptomatic of a deep wariness on the part of the late-medieval artist about what we would call industrial espionage: the loss of control of innovative, unique material. Our lack of knowledge about important aspects of the painter's work may reflect not only the loss of essentially oral workshop traditions, but also a quite self-conscious concealment of method, the method of the craft 'mystery'. Medieval culture reserved high praise for images apparently not made by human hands at all but by divine agency or by angels, their supernatural manufacture defying precise explanation. Modern art-historical method, on the other hand, is geared primarily to explanation, to uncovering the 'realities' of production.

Technique and knowledge varied greatly throughout medieval Europe, and the methods employed by painters depended very much upon the types of materials and traditions available to them. Geography determined the supply of materials and the climate with which

54 Prophet figures from the Pepysian sketchbook, *c.*1400.

finished paintings had to cope – vital practical considerations which were uppermost in the painter's mind. Italian panel paintings use completely different materials from those produced north of the Alps, for example. Italian painted altarpiece panels are made almost invariably from a timber *support* of soft poplar wood, glue and nails, reinforced with linen canvas; a *ground* of white gesso (i.e. gypsum) on which drawing, gilding and painting were done; and tempera paint in which the *medium* is egg. North of the

Alps, however, entirely different materials are found. Hard oak was employed for the manufacture of panels; vellum (i.e. sheepskin) as well as linen was used to reinforce the timber joints; grounds tend to be of chalk, not gypsum; and there was much greater flexibility in paint medium, linseed or walnut oil often being found by itself or with tempera. Cennino says oil painting was the medium preferred by 'Germans' (i.e. northerners), unlike Italians. Modern scientific analysis of Gothic panel paintings has

55 Duccio's triptych showing the Madonna with Saints Dominic and Aurea, *c*.1300. A typical example of Italian tempera painting on gessoed poplar wood.

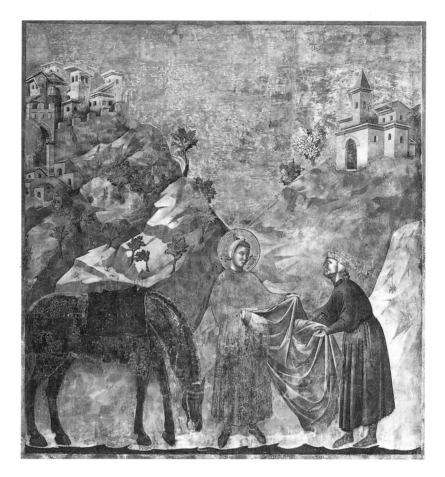

56 *Right* Fresco, late thirteenth century, from the Life of St Francis in the upper church of San Francesco at Assisi.

demonstrated that he was quite correct: linseed oil paintings survive from as early as the thirteenth century in England and Norway, and the technique appears to have been much less important in Italy. The materials used for the support and ground reflect the distribution of medieval European flora and geology; oak and chalk were plentiful north of the Alps, whereas Mediterranean countries suffered from a dearth of hardwoods but had good gypsum supplies, and so on.

Wall painting also displayed remarkable variety. In Italy, painting quickly and directly on to freshly-laid wet plaster, or *fresco*, was common throughout the later Middle Ages. Yet combinations of fresco with painting done *secco* on to dry plaster, or over already-dried colours, were normal, and sometimes Italian murals, such as those by Giotto in the Peruzzi Chapel in Santa Croce, Florence, are wholly secco. The technique used depended on the pigments (some blue pigments needed a tempera medium) and even on the season of the year. North of the Alps the pattern was also complicated. Forms of fresco painting, dependent ultimately upon Byzantine techniques, were used throughout Europe in the Romanesque period: Theophilus refers to a variant of the method whereby lime painting is done on wetted but not fresh plaster. But fresco was increasingly abandoned or relegated to preliminary colouring stages from the thirteenth century onwards, just when Italy was reviving the technique. Thereafter, the usual technique for Gothic mural painting consisted of 58

59

57 *Opposite* Altar frontal from Tingelstad, Norway, second half of the thirteenth century. The panel mixes tempera with drying oils and uses a timber support of pine reinforced with canvas, and a chalk ground. Style and technique thus both differ radically from contemporary Italian practice.

58 *Right* St Faith, in the refectory of the Priory of Horsham St Faith, Norfolk, *c.*1260: a magnificently well-preserved example of full-colour Gothic secco wall painting.

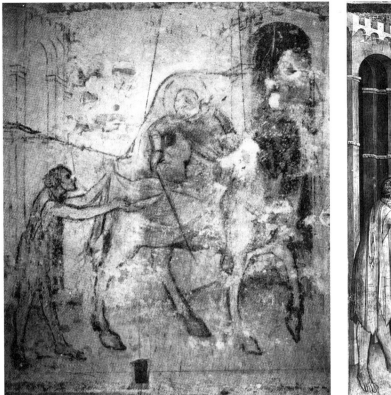
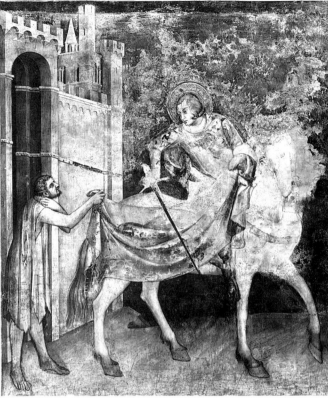

59, 60 Simone Martini's *Charity of St Martin*, from the lower church of San Francesco, Assisi, *c.1320*. The painter's thought processes have been revealed by the removal of a fresco. The sinopia drawing (above) provides a basis for the fresco painting, but not all its features (for example, the position of the beggar's left arm) are retained in the final version (above right).

secco painting, with lime water or tempera media, over outline drawings in a reddish chalky material called *sinopia*. Even oil painting on a lead white primed ground occurs in some wall paintings north of the Alps. For this reason it is usually quite incorrect to call a northern Gothic wall painting a fresco; nor can the term always be used with absolute confidence in Italy.

Regional aesthetic tradition was also a powerful force. The areas, principally around the Mediterranean, which developed fresco painting coincided closely with those which had long practised monumental mosaic decoration. This may have been because the techniques of mosaic and fresco were related, despite their being separate art forms. Some notable Italian painters of the late thirteenth century, such as Cimabue, Cavallini and Giotto, worked in both media before mosaic passed out of fashion. In mosaic, the coloured stone or glass *tesserae* or cubes

were pushed into a layer of soft fresh plaster, laid in turn over a thicker plaster layer upon which the preliminary design was drawn out. Work proceeded stage by stage across the surface of the mosaic, starting at the top, in accordance with how many cubes could be set into the fresh plaster at each session. This order of work, with several plaster layers and a top-to-bottom procedure, was followed also by fresco painters. In fresco, the wall to be painted was also rendered with a rough plaster, the *arriccio*, upon which the design was drawn in charcoal assisted with incisions, or *sinopia* drawing. Over 59 this ground a final fine wet plaster, the *intonaco*, was laid in patches large or small enough for the painter to cope with: he painted directly on to the *intonaco* while bearing in mind the design on 60 the *arriccio* beneath. Obviously some things are harder to paint than others; faces took longer than garments and were more likely to be

reserved for the master painter to do and, as a result, in Giottesque painting they occupy smaller patches of *intonaco*. By analysing the work patches of a fresco we can establish roughly how quickly (in terms of area) a painter worked — and they worked with surprising speed — given that much finishing would be done in tempera on the dried *intonaco*.

Apart from these widespread technical differences, the day-to-day business of wall or panel painting was probably fairly uniform throughout western Europe. Painters worked in teams under a master, and observed a strict division of labour. They used wooden scaffolding (often alder-wood) for wall painting. They established preparatory grids on walls by using long cords held tightly across the face of a wall and then snapped against the plaster like a bowstring, to leave dead straight lines for the

61, 62 Lead stencil (right) for a rosette design (below), thirteenth century, from Meaux Abbey, Yorkshire. The rose was a commonly-cited example of beauty in the Middle Ages.

63 *Far right* Standard thirteenth-century masonry pattern with rosette decoration, at Selling Church, Kent.

An oyster shell colour-dish retaining traces of pigment, probably fourteenth-century, found in Boyton Church, Wiltshire. (See colour-dishes in use in figs.**3**, **7**, **8** and **51**.)

painter to follow. Painters made and repaired their own equipment, such as miniver, squirrel or hogshair brushes, lead stencils, wooden stamps for working in gesso, and wooden or shell palettes. They, or rather their apprentices, ground their own pigments and, according to Cennino, mixed them in a system of dishes to retain the purity and consistency of the colours.

The painter's control of his work and materials was of course a means of guaranteeing quality. Yet some aspects of his work fell outside his control. Wall painters seldom controlled the shape of the walls they were commissioned to paint. Similarly, there is evidence, primarily from Italy, that, from the fourteenth century, panel painters did not always make the timber components of their increasingly large and complex altarpieces. Cennino writes of preparing the timber of an *ancona* as if it were already carved and assembled, the painter adding gesso and sculpting it to refine the joiners' work. Such developments simply reflect late-medieval craft specialisation. In the fourteenth century several notable panel painters, such as Pietro Lorenzetti and Taddeo Gaddi, worked upon panels contracted separately from the painting. The panel, as completed by the joiner, was strictly the property of the client, the painter's work being regarded as just another stage in its working. As altarpieces became more complex, it is probable that painters provided a design prior to the execution of the woodwork, in order that the timber frame could incorporate the correct number and size of compartments for figures.

What would strike us about the production of a great painted altarpiece, if we were privileged to see medieval methods actually at work? The first and abiding impression would be of the number and complexity of the different tasks, and the extreme lengthiness of their execution. Cennino Cennini's handbook presents patient methods of preparing gessoes, glues, pigments and varnishes in almost ritual, incantatory form, a by-product of the empirical means – like good cooking – by which methods had been arrived at in the first place. A large workshop would have several commissions in hand at any one time, in various stages of completion, some awaiting gilding on a damp day, others gessoing on a dry and windy day. Much the bulkiest components on the shop floor (and painters' workshops are likely to have occupied ground floor premises for this reason) would be the pre-assembled timber surfaces for huge painted crosses or altarpieces. These were assembled from planks of various sizes held together with glue, pegs and nails, and with elaborate but often quite rough wooden battening on their backs to support them. Exceptionally large altarpieces like Duccio's *Maestà* may even have had scaffolds erected in front of them to paint them from top to bottom, like a fresco.

The painter began by preparing the timber. Wooden panels of all types were given a ground of gesso or chalk mixed with water and size respectively, depending on the region. This ground was then either incised with the designs for figures (as in Scandinavian panel painting), or drawn with charcoal and ink (as in Sienese). The gilder came in next, following the designs and

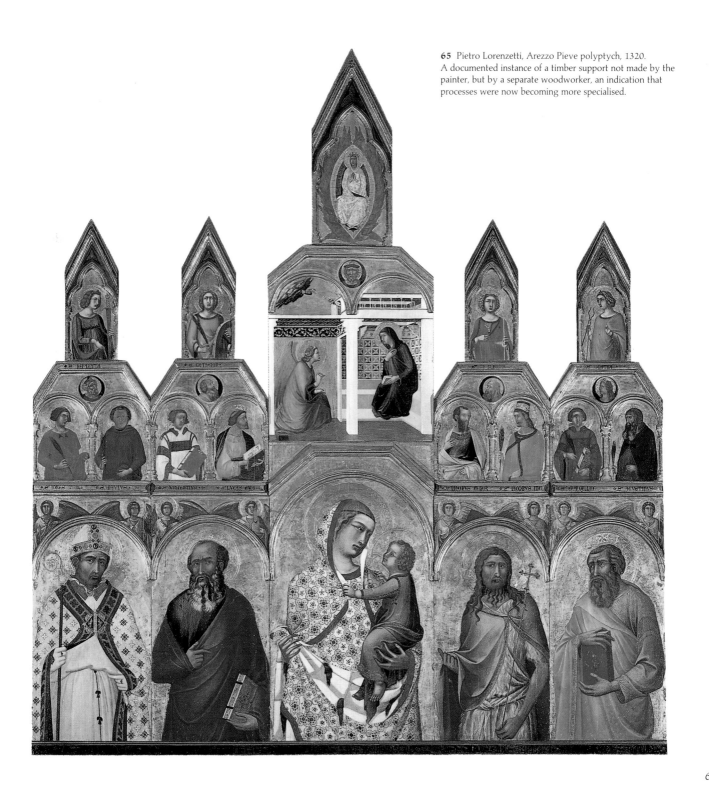

65 Pietro Lorenzetti, Arezzo Pieve polyptych, 1320. A documented instance of a timber support not made by the painter, but by a separate woodworker, an indication that processes were now becoming more specialised.

66 Relief-modelled gesso and minute punch marks decorate a predella by Jacopo di Cione, Florence, mid fourteenth century.

laying his gold leaf on to those areas of the ground that were not going to be painted, often on to a thin coat of reddish clay, called *bole*, laid on the ground. Next, the gilded panel could be embellished with incisions or punches made with small hand-cut metal implements; again, depending on the region, the patterns could be simple incisions (as in thirteenth-century panels made north of the Alps) or incised and punched patterns (as in almost all fourteenth-century Italian work), rendering the panel in appearance like a splendidly engraved gilt sheet of metal.

By the time the brush came to be employed, in other words, the painter had in front of him an object already thoroughly manipulated, gilded and tooled, like some piece of goldsmith's work. Medieval paintings were in a sense framed before they were painted. They were conceived as parts of ensembles, often installed in ritually important areas of churches traditionally as-

sociated with brilliantly-worked metalwork used in the liturgy. The luminous appearance of many panels rendered them akin to *ars sacra*, sacred art. Their techniques sometimes resembled precious art forms. Thirteenth-century Norwegian painters coated their altarpieces with silver foil, and then painted in the figures in thin glazes of colour mixed with oil or tempera, which allowed the foil to shine through the colours as through a translucent, seemingly precious enamel. Another technique was to set the wooden gessoed frame with glass beads, panels of putty painted in imitation of enamel, or other, larger, areas of coloured glass set on reflective grounds and coated with gilded patterning. This method was used in the wall paintings in the Sainte-Chapelle, and on the late thirteenth-century Westminster Retable in Westminster Abbey. Since the glass used in this operation was the same as stained window

67 Job, a detail from the St Stephen's Chapel murals, formerly in Westminster Palace, *c.*1350–60. The ground has been treated with embossed red lead, from which the gilding has worn off. The medium is oil paint, similar to a panel painting, but technically alien to some of the Italian sources influential in the style.

68 St Peter, from the Westminster Retable, Westminster Abbey, late thirteenth century. One of the most decoratively complex altarpieces in existence, the paintings are executed in linseed oil and the minutely-carved oak frame is set with glass plaques, jewel-like beads, paste cameos and imitation enamels.

glass, painters must sometimes have called in trained glass-cutters. A similar technique, called *verre eglomisé*, was used in fourteenth-century Sienese panel painting. 70

Many such panels are gorgeous confections of wood, paste and glass, illustrating the high artifice, the *ingenium*, of the painter and his assistants. Such confectionery took time to execute, and the actual process of applying coloured paints was always the last, the colour adjusting itself to the splendid context of the completed frame. Whether working in oil or tempera, the medieval painter created his images as if applying the subtlest of facial cosmetics. Colour was laid in sequentially over preliminary drawings done by the head of the workshop. Normally, and in this respect panel and miniature painting were identical, coloration would begin with the application, or laying in, of flat unmodulated tones on flesh and garments, work which could be done by a lesser painter to spare the master. Depending on the degree of finish required, this painter, or more likely one superior to him, would add darker shading to the laying-in colour, in the process known as *incidere* (a term used in some technical treatises of the period) – literally 'to incise', as in engraving or metalwork. By the early fourteenth century a third tone, lighter than the other two and consisting of the first laying-in tone mixed with white, would be added to highlight forms, in the process called *matizare*. Each stage of this sequential process was more decisive, more form-orientated, more responsible. Within the confines of the three-stage method of coloration (single and two-stage coloration were practised by many earlier medieval painters), tradition and the inclinations of the master tended to determine how the stages were actually blended – whether smoothly merged into one another, or whether laid over one another in minutely even parallel strokes, almost like chisel marks.

The analogy with the chisel, the painter as *imagier*, leads us finally to recall the numerous correspondences between painting and other crafts in the Middle Ages. Often in the course of this book we have seen how painters were perceived socially as craftsmen, how they or-

69 The Raising of Jairus'
Daughter from the Westminster
Retable. See fig.**68**.

ganised themselves in ways closely resembling those of other crafts, how they were manufacturers as well as visualisers, and how their habit of mind presupposed a finished, ready-framed, context for their work. Yet what remains mysterious, and in the end most fascinating, is the nature of the creative processes they engaged in, processes not reducible to the age-old formulas of recipe-books and model-books, nor to the language of stylistic change or patronage or scientific insight, processes in many ways lost from view and yet dimly perceived through the veil of their surviving work. Much has yet to be done before the medieval painter can be better and more sympathetically understood.

70 *Left* A fourteenth-century Sienese *verre eglomisé* panel showing the Madonna.

71 *Below* A young conservator from the Courtauld Institute follows in the footsteps of the medieval painter.

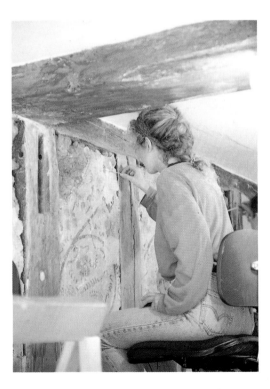

FURTHER READING

General

V. W. EGBERT,
The Mediaeval Artist at Work,
Princeton, 1967. An illustrated
introduction.

A. MARTINDALE,
*The Rise of the Artist in the
Middle Ages and Early
Renaissance*, London, 1972.
A concise and entertaining text.

Technical treatises

*Art in the Making: Italian
Painting before 1400*, National
Gallery exhibition catalogue,
London, 1989. Contains a
comprehensive and up-to-date
bibliography on Italian painting
technique, together with useful
technical data.

*The 'Painter's Manual' of
Dionysius of Fourna*, trans. PAUL
HETHERINGTON, London, 1981.

D. V. THOMPSON,
*The Materials of Medieval
Painting*, repr. New York and
London, 1956.

THEOPHILUS,
De Diversis Artibus, ed. and
trans. C. R. DODWELL, London,
1961.

CENNINO CENNINI,
*The Craftsman's Handbook: the
Italian 'Il libro dell' arte'*, trans.
D. V. THOMPSON, repr. New York
and London, 1954.

Specialised studies

M. BAXANDALL,
Giotto and the Orators,
Oxford, 1971.

E. BORSOOK,
The Mural Painters of Tuscany,
2nd edn, Oxford, 1980.
A standard discussion.

P. HILLS,
The Light of Early Italian Painting,
New Haven and London, 1987.
Considers colour and light.

J. MARETTE,
*Connaissance des primitifs par
l'étude du bois*, Paris, 1961.
A study of timber construction
in medieval painting.

P. MORA, L. MORA and P. PHILIPPOT,
Conservation of Wall Paintings,
London, 1984. An exemplary
introduction to medieval and
modern painting technique.

L. PLAHTER, E. SKAUG and
U. PLAHTER,
*Gothic Painted Altar Frontals from
the Church of Tingelstad*, Olso,
1974. Scientific examination of
early northern Gothic panels.

J. B. SOBRE,
*Behind the Altar Table: the
development of the painted retable
in Spain 1350–1500*, Missouri,
1988. Publishes new
documentary evidence for
Spanish medieval painting.

E. W. TRISTRAM,
*English Wall Painting of the
Fourteenth Century*, London,
1955. Slightly outdated but full
of valuable social material.

J. WHITE,
Duccio, London, 1979. Contains
lucid discussions of workshop
practice.

ACKNOWLEDGEMENTS

The author is most grateful to
Athena Reiss for her assistance
in the research for this book, to
Celia Clear and Rachel Rogers
and Johanna Awdry at British
Museum Press for their unfailing
assistance, and to David Park
for his help with photographs.

Extracts in the text from
contracts with the painter
Duccio are taken from J. White,
Duccio, London, 1979; passages
concerning Spanish
apprenticeship, contracts and
maladroit painters are taken
from J. B. Sobré, *Behind the
Altar Table: the development of
the painted retable in Spain
1350–1500*, Missouri, 1988.

INDEX